WITHDRAWN

Landscape painting for beginners

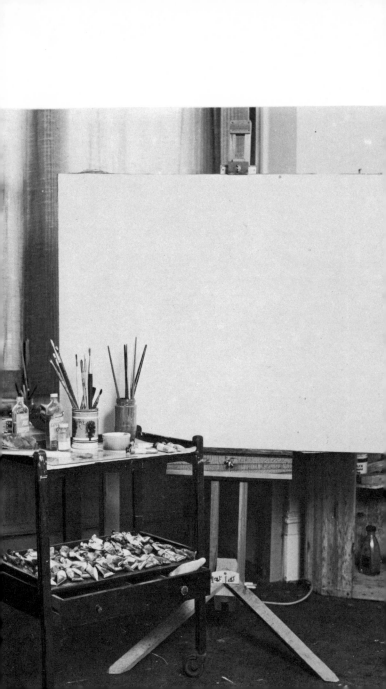

Landscape painting for beginners

Joanna Carrington

Studio Vista London

Acknowledgements

Fig. 15 is reproduced by kind permission of Her Gracious Majesty the Queen; figs. 40, 48, 55, 57, 63, 65, 70, 72, 75, 77 and 79 by permission of the Tate Gallery, London; figs. 51, 53, 54, 56, 58, 64 and 67 by courtesy of the Trustees, The National Gallery, London; fig. 49 by permission of the Trustees of The Wallace Collection, London; fig. 59 by courtesy of The Ashmolean Museum, Oxford; fig. 76 by permission of the Waddington Gallery.

The author would also like to thank the following for allowing their pictures to be reproduced: Diana Armfield for fig. 52; Sheila Fell and the Stone Gallery, Newcastle-upon-Tyne, for figs. 73 and 78; John Craxton for fig. 80; and Alaistair Flattely and the Royal Academy, London, for fig. 81. Grateful acknowledgements are also due to John Murphy for his original photographs.

General editors Janey O'Riordan and Brenda Herbert
© Joanna Carrington 1971
Published in London by Studio Vista Limited
Blue Star House, Highgate Hill, London N19
Set in 9 on 9 $^1/_2$ pt Univers
Printed and bound in Holland by
Drukkerij Reclame N.V., Rotterdam
SBN 289.79779.9

Contents

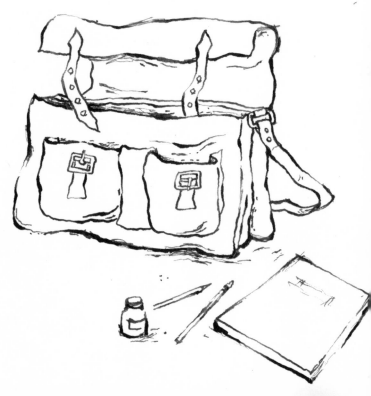

'For the Artist, communication with nature remains the most essential condition. The Artist is human, himself nature; part of nature within natural space.'

Paul Klee – *Pedagogical Sketchbook,* Faber & Faber 1925

Introduction

During week-ends or holidays people are searching for the peace that can be found in the country-side. It seems to be a universal need. For some it is enough to walk through fields or click a camera or just sit in a car and gaze, but many others would like to express what they feel about beautiful landscape and one wonders why the land is not crowded with people painting and drawing. The answer could be that although many would like to do so, few feel sufficiently confident to take the first step.

What is seldom realized is that it is not necessary to have talent in order to paint a landscape. Indeed, those with no recognisable flair have a real advantage over the so-called gifted painter. He may be able to slap down a cottage, a sunset or river reflections with no difficulty, but this often fails to communicate anything and the result is likely to be a clever but impersonal picture without much originality.

Sometimes one hears the plaintive cry, 'But I can't even draw a straight line'. Neither could Van Gogh when he began, but it did not deter him or many other great painters. It is often the very struggle to make a ploughed field look and feel like one that will give it a special and personal meaning. There are a few people (and Grandma Moses was one of them) who are so unusually confident and determined that they need neither instruction nor encouragement. On the other hand, there are many who have enthusiasm but lack confidence. It is for these enthusiasts that this book is written.

I have chosen oil painting as the medium, partly because it is the medium I know best, and partly because it is one of the easiest media for beginners to control. You can change an oil painting, paint over it, scrape it down, move colours and forms about. In fact, once you have mastered painting in oils, the handling of other media such as water-colour, acrylics, or pastel, will come more easily.

There are three methods open to the painter of landscape:
1 Painting at home, working from drawings and notes made on the spot
2 Painting on the spot
3 Painting from imagination, or from memory

Of the three methods, I advise the first one for the beginner. This may come as a surprise, but there are a number of good reasons

for starting off in this way. Painting direct from nature is enormously valuable at a later stage, but for the beginner it can be very confusing. Where do you begin? Where do you stop? There is so much in front of you, how do you decide what to put in and what to leave out? The light is constantly changing. Your colours and brushwork can become sticky and difficult to work with. Therefore, I suggest your first few landscapes be done from sketches and drawings — away from the scene that inspired them. Later, when you have learned to be selective and to handle colours, allow yourself the luxury of painting on the spot (see chapter 7).

The greatest advantage of the first method is that, away from the landscape, you have a better chance of capturing the things which really matter. You will retain the essential idea in your mind. With the help of your memory, and your notes and drawings sorted out in the studio or hotel bedroom, you will produce a more convincing painting than the one you would have managed out of doors. You will find it easier to look at your picture as it develops. Dust and flies or the glare of sunshine could spoil your concentration, and it is simpler to carry a sketch book and pencil or pen out to the fields than the paraphernalia necessary for painting. Drawings can be done quickly. You don't need a whole day of uninterrupted sunshine. Back in the studio you can take your time — a day or weeks, it does not matter.

The aim of this book is to help you learn how to paint a landscape, but first you must learn how to see, draw and compose. With this in mind, I shall take you through my own process step by step.

My intention is to guide, not dictate. It must be remembered that there are no rules in art other than those which you make for yourself. At any point you can, and eventually will, depart from my method to discover your own.

Exploring and discovery is what painting is all about. There is no mystery other than that which you yourself possess or feel. A painting is only as unique or individual as the person who painted it and, of course, we are all unique.

Everyone is capable of experiencing intense pleasure from the sight of a lovely landscape. Everyone can also communicate those feelings in paint once the language is learnt. Learning the language is just a question of determination. It is such an absorbing and exciting process that it is like an adventure without end.

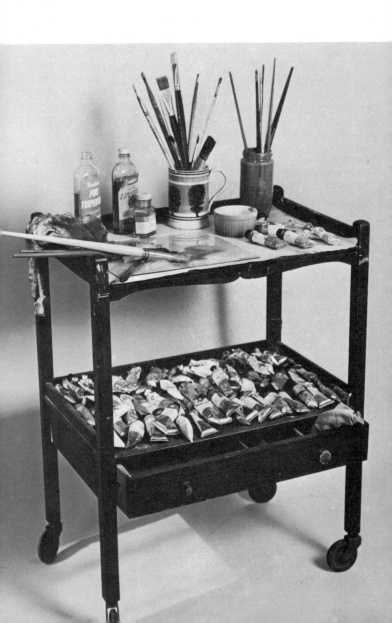

Fig. 1 An old tea trolley (small serving table) is a valuable asset in the studio. It holds all your materials, and has the great advantage of being mobile

1 Materials and equipment

Painting need not be an expensive or complicated occupation. Your essential equipment can be very simple. To my basic list you will probably add further supplies as time goes on, because painters vary widely in their needs.

To begin with, it is not essential to have a large studio, an easel or 101 brushes. Any well-lit corner of a room will do as a place to work. Your canvas can be propped up on a table, chest of drawers or ledge. A sheet of glass, enamel or a white china plate can be used as a palette and a cardboard shoe box as a container for the paints.

The only essentials to be bought, then, are drawing materials, canvas or some other support, a few brushes, medium and, of course, colours.

Drawing materials

Drawing Book This should be hard-backed and large enough to allow for generous drawings, yet not so large that it does not fit comfortably into briefcase or shopping bag. I recommend a drawing book with perforated pages of smooth white paper, approx. 11 ins × 8 ins.

Pencils All my drawing is done with a soft, frequently sharpened, 6B Venus. This pencil allows for the maximum variety of tone from inky black to the palest grey. The alternative is to have a range of pencils from 6B to HB.

Sharpener A strong pencil sharpener, penknife, or razor blade is, of course, essential.

Eraser This is not necessary, and makes for fussy drawing. Simply begin again on another page.

Pens Probably the best pen to work with is your own fountain pen, or the one which you feel most at home with. Failing this, art suppliers stock a large variety to choose from including the felt nib, the relief nib and ink and so on. Ballpoint pens are best avoided, as with these it is difficult to obtain the thick or thin lines and the differences of form and tone necessary to the drawing.

Viewfinder

This useful addition to the landscape painter's equipment can easily be made, by cutting out a small rectangle in a sheet of cardboard (fig. 2). It's use is explained on page 21.

Camp stool

A low camp stool provides a more comfortable position for drawing and encourages greater concentration, although it is not essential if you use a hard-backed drawing book.

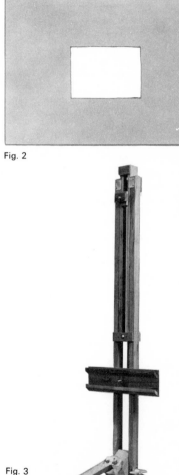

Fig. 2

Clothes

The clothes worn for outdoor work should be, first of all, comfortable and practical. You may have to clamber over barbed wire, through hedges, and across streams. In cold weather, adequate clothing is vital. You may warm up when walking, but standing or sitting is another matter. Feet are the first to suffer in cold weather, and warm fur-lined boots are an asset. In the winter I always wear a campari jacket (a long quilted and waterproof jacket with hood and plenty of pockets) bought at an Army surplus store.

Fig. 3

Studio Equipment

Easels As I have said earlier, an easel is not essential, but if you are going to invest in one, then make sure that it is sturdy. A folding easel which can be used for outdoor work, in friends' houses, hotels, etc. is useful, but will tend to wobble, and better no easel than one which wobbles.

The type of easel known as 'radial' is excellent for use at home (fig. 3). It is strong, firm and takes a canvas of up to 52 ins in height. Sometimes one can pick up an old easel secondhand.

Otherwise, an old blackboard stand, while having the disadvantage of not being able to tilt forward as an easel can, does provide a sturdy substitute, and is to be preferred to painting against the wall on a table.

Palette The traditional thumbhole palette is very necessary for outdoor painting, but in the studio it tends to be cumbersome, and it is better to have your hands free.

A sheet of glass with white paper underneath makes an excellent palette. Whatever you use, glass, plastic, china, enamel or wood, I recommend a white surface. White shows the true colours better than brown.

If you are painting on a table against the wall, then the front of the table serves as a convenient ledge on which to place the palette.

If you are using an easel, you will need a small table, chest or crate near at hand. I cannot recommend too highly a tea trolley (small serving table). I was lucky enough to find a disused one in someone's garage. It has the tremendous advantage of being able to contain all one's materials, palette, brushes, paints, oil and turpentine and yet be mobile (see fig. 1, page 10).

Canvas, board etc. Whether you paint on canvas, hardboard, plywood or any other surface, is a question of time and taste rather than economy. It is not difficult to prepare the support or, in the case of canvas, to stretch and prepare your own (see chapter 9, page 85).

Either way, always prepare or buy several canvasses, or boards, in different sizes and shapes. Although you may be the kind of painter who works on only one painting at a time, it is inhibiting not to have other canvasses on hand.

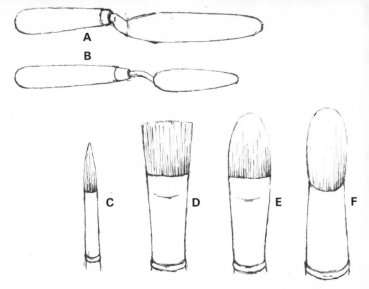

Fig. 4 **A** cranked-blade palette knife **B** trowel-shaped palette knife **C** pointed brush **D** square-ended brush **E** filbert-shaped brush **F** round-ended brush

Brushes (fig. 4) Well-cared for, brushes last for years. If you can afford the outlay, the wider the choice the better, since it allows for a wider variety of brush-stroke, but about six brushes are sufficient to begin with.

Sable hair is expensive, and, as these brushes are intended only for very fine work, unnecessary. The cheaper hog hair (bristle) brush is suitable for general purposes.

The round-end and filbert-shaped brushes are useful for the earlier stages of painting, for rubbing in and scumbling work (see page 74). The flat, square-ended brush is designed for the laying on of paint, and textural brushwork. The pointed brush is, of course, used for linear and more exacting work. For the beginner I would recommend:

1 large round end
1 medium filbert
3 different sizes of flat square
1 pointed medium

Household brush In addition to the above, an ordinary house-painting brush, 2 ins wide, is useful for any undercoating or colouring required, and even for blocking in thinly the first colour forms.

Palette knife One palette knife is quite sufficient, provided it is both supple and strong. It can then be used both for scraping

14

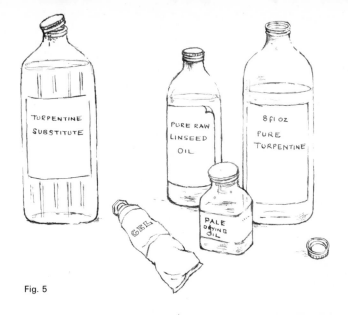

Fig. 5

down paint from canvas or palette, and for the mixing of colours or application of paint. I recommend a cranked-blade palette knife or a trowel-shaped knife (fig. 4).

Turpentine and turpentine substitute An essential in the studio. For cleaning brushes, palette etc., turpentine substitute may be used. As a medium for thinning the paint, pure turpentine only should be used. It is quick-drying, but it must be remembered that turpentine used in excess dries out and removes the gloss and vitality from the colours. In the latter stages of the painting, it is advisable to use a mixture of linseed oil and turpentine (see page 51).

Linseed oil and drying oil Linseed oil is the traditional medium used with colours to make them flow more easily without losing their vitality. Unfortunately it is very slow drying and for some painters' needs the faster drying pale or light drying oil, which has only a slightly thicker consistency, is a good substitute.

Other mediums There are many other mediums available on the market, but poppy oil, stand oil, and copal oil are even slower drying than linseed oil. Recently introduced are some plastic-based mediums usually sold in tubes, such as acrylic gel. These dry very rapidly and are most useful for glazing techniques (see page 58) and as painting mediums.

Fig. 6

Containers Use tins or jars for your mediums and a large jam jar of turpentine substitute for washing brushes. The little dippers obtainable in art shops are only useful for clipping on to the side of a palette.

Paints The wide range of different colours available in oil paint can seem alarming to the beginner. The problem of choice is not made any easier by the fact that different manufacturers produce different shades of the same colour, and sometimes they are all called by the same name. Until the names of different makes and their properties are known, it is as well to unscrew the tops and inspect the colour before buying.

Nothing is gained by the use of cheap student colours. These tend to have chalk and other pigments added. The more expensive Artist's colours have an intensity and purity which means that a little goes a long way.

Some painters mix their own colours by buying them in powder form, grinding and mixing them with linseed oil. The mixture may then be kept in sealed tins or jars. Although economical, it is a fairly messy and slow business. I would not advise it for the amateur.

Except when buying a colour for experimental use, be generous with the size of tube. Small tubes of paint tend to make one stingy. Provided lids are screwed on securely, the paints will last

for years. Fig. 6 shows tubes of three sizes. Always buy a large tube of white, medium-sized tubes of your main colours, and small tubes only of expensive glazes and experimental colours.

Every artist has his own favourite colour, or colour range, so that in providing a list of suggested colours, I must point out that this is my own personal choice for landscape painting, and not an exclusive one.

You will notice that I have not included black. It is advisable to mix this colour for yourself from blues and browns. Black dirties a colour more than it darkens it and is best avoided altogether.

Also best avoided are any of the chrome yellows. They are unreliable mixed with certain other colours, turning dark when exposed to the light.

Personally, I am inclined to be greedy and stock an enormous range of different colours. This is quite unnecessary and the list below is sufficient for all general purposes:

Titanium or Flake White

Cadmium Yellow pale	Cadmium Red deep
Yellow Ochre	Winsor Violet*
Raw Sienna*	Winsor Blue*
Vandyke Brown	Alizarin Green*

I also use, but in smaller amounts, the following colours for glazing work (see page 58).

Olive Green (dark) or Sap Green
Italian Pink
Indian Yellow
Rose Madder
Terre Verte

These are transparent colours, as are the ones marked * in the first list. The reason it is necessary to buy Cadmium Yellow pale rather than medium or deep is that a pale yellow may always be made deeper by the addition of red or brown, but a deep yellow cannot be made paler without the use of white which means it must lose much of its strength and intensity. The reverse applies to Cadmium Red deep.

Fig. 7

Fig. 8

Outdoor Painting

I have already dealt with most of the materials and equipment you will need for landscape painting. However, in the case of outdoor work, there is the question of transport.

Of course, the traditional oil sketch box, complete with brushes, paints, palette, dippers and medium is one way of carrying the materials, but this is an expensive item.

Just as good is a large rucksack or satchel that can carry a folding easel as well. This leaves your hands free. The paints should be placed in a cardboard or tin box to prevent damage. The brushes can be either wrapped in newspaper or placed in a cardboard roll or a long box. Oil-colour brush cases can be bought; they are most useful, but add to the weight. Oil and turpentine must be kept in well-screwed-down bottles or jars. Don't forget a paint rag.

Palette and dippers Indoors, the thumbhole palette is inconvenient, but for outdoor work it is an essential. A pair of clip-on dippers for the mediums are also necessary.

Canvas pins Carrying a dry canvas is no problem. A newly-painted wet canvas in a strong wind is quite another matter. With this in mind, you should buy four canvas pins. These are two-ended pins of cork or plastic (see fig. 7). Two canvasses of the same size should be taken on the expedition. When painting is completed, place the four pins in each of the four corners of the wet canvas, then lay the other canvas on top and with very little pressure they will be held together without actually touching (fig. 8).

18

2 The working drawing

The working drawing, as opposed to other kinds of drawing, is used in the studio as a guide to the landscape you want to paint.

It is, therefore, important to remember that you are not out in the fields to do anything but discover and record informative data for the painting to come. It is not supposed to be a finished drawing, something to be framed and hung, nor should it look like one. Indeed, to someone else it may well appear an indecipherable mess, scribbled over with notes about colour, light and wind. But to you, every line, scribble and splodge should indicate essentials about that landscape which you don't want to forget. The drawing or drawings which you bring home should capture the character and essence of a particular place, and in the maze of pen or pencil marks, the one quality that first inspired you regarding that particular field or mountain should still remain.

It is vital that the drawing should inspire you to paint, just as the original scene inspired you to draw.

What to include

The secret of this kind of drawing is to weed out the inessentials and concentrate on the important things, so that when you come to paint, you have already made all the big compositional decisions and your task is simplified. This is why it is often necessary to do more than one drawing, each conveying a simple idea.

To most people who are starting out, it is the compositional decisions that they find most puzzling: whether to put in this tree or that, how much of the road, how little sky etc.

Obviously one cannot put in every blade of grass, every leaf on a tree, or draw the precise shape of a moving cloud. On the other hand, where do you make the choice between the simplified abstract shape of a tree and the mass of minute detail which is clearly visible? As I have previously said, there are no rules, but in the following pages I will try to show how I set about this problem and others as they occur in a single landscape.

To see the potential in what may first appear a dull and uninspiring subject often requires a second look. A landscape painting is not made exciting just because it contains dramatic mountains or rushing streams. A single field or patch of waste land can make a lovely painting and be just as interesting to paint once the eye has seen and recognized its peculiar qualities.

Below is a photograph of a field and trees in Berkshire, a simple scene which caught my eye one day on a walk. Later, I returned with drawing book and pencil. I did not sit down and begin drawing straight away. My first job was to analyse my reasons for wanting to draw this particular landscape in the first place. This is important, because it is the beginning of the selective process which tells you what is essential and what is not. In this case, I stood in the road, climbed a bank, entered a field and studied the scene from all angles, before returning to the road again.

I came to the conclusion that what pleased me about this subject was a mixture of two factors: one was pattern, the other mood. The mood was the element that must be preserved at all costs. Unfortunately the photograph, flattening the line of hills as it does, fails to do justice to the little valley that inspired me. What I in fact saw was a landscape compounded of fitful but brilliant sunshine, a cold hard wind, and scurrying clouds.

Fig. 9

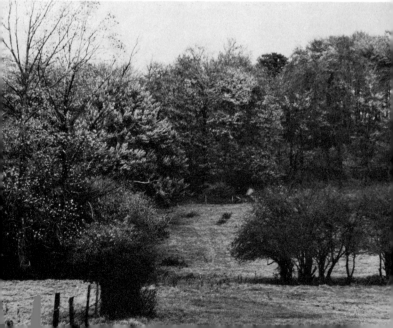

There is nothing quite like the liquid uncertainty of the English light in November. Nothing could be more changeable. Yet in complete contradiction to this lay the peace and permanence of fields and forms that had not changed in years.

This, of course, was not all. The scene had a quality suggesting that nothing else lay beyond. It was a complete world in itself. The reason for this seemed to be in the position of various trees and shapes in relation to one another.

The curve and line of the fence which led the eye in one direction was arrested by a fierce little group of thorn trees. The thorn trees curved one way, the fence another, creating tension or a sort of tug of war. In addition, the tree on the left took a sudden curve in its trunk. The landscape was all movement and curves, and it occurred to me that even the clouds seemed to have adopted a similar dancing rythm. Above all, the colours, brilliant and autumnal, made this normally ordinary little scene quite spectacular.

These were just some of the thoughts that ran through my head before I even put pencil to paper.

I had not yet decided how much of the scene to include in my picture. Beginners often find this a hard choice. I recommend a viewfinder to help you decide. This is a piece of card with a rectangular hole cut out of the middle (see fig. 2 page 12). Hold this up and squint with one eye through the hole, and your land-scape is already framed. Is that tree on the right going to be too large? Will it look comfortable placed right on the edge of the canvas? Move your position slightly to obliterate it or bring it further into the centre. You can soon tell where it will look best. This is what composition is all about. You are taking a small section of a vast landscape and fitting it into four sides of a rect-angle, your aim being to make a satisfactory whole out of many parts.

To create a complete landscape within these four sides, all the shapes within it *must* look comfortable. What you have to decide is how much or how little of the landscape spread before you will fit into your idea of the landscape as a whole. Sometimes one tree will say all you want to say about a particular landscape. Sometimes you may find it necessary to include the tree, the wood, the hill and the cottage. A viewfinder will help you make these decisions. In the case of my Berkshire landscape, I found

that the central pivot of the scene was the gap or space between the thorn bushes on the right and the bush and trees on the left. I decided that I could safely cut out the fence immediately in front of me. There were also some cows and a gate which, I decided, were irrelevant and would only clutter up the picture.

How much sky should be included? This, too, can be a difficult choice. Any landscape is immensely affected by its sky, the position of the sun and the amount of wind and cloud. It was Constable's great love for, and understanding of, the sky that made him such a great landscape painter. He understood light. In flat or open country, I tend to give a greater proportion of canvas space to the sky. In steep hilly or wooded country, I give the sky less space, or sometimes none at all. But even here a feeling of light and sky above must permeate the landscape (see page 56). It is risky is to give land and sky equal space. To do so tends to cut the picture in half. Chapter 4 will tell you more about the problems of composition.

Beginning the drawing

If you are out of practice, and particularly on a cold day, your hands will tend to be stiff, and it is going to take a little while for your hand and pencil to work easily together. The first sketch may have to be considered a warming-up form of exercise. Do not expect too much from it. At this stage, relax; be a more severe critic later on.

The pencil must learn to obey the hand, the hand to obey the eye. The eye must learn to observe means of translating, not copying, nature. I usually do my first drawing quickly and roughly, allowing time to loosen up, getting used to the subject and attempting to capture something of the mood and atmosphere.

The next problem is where to begin. The sky, one tree or several? I think it is wise to begin by putting in the main lines of land form.

In the case of my own landscape, I could scarcely see the form of the land for the quantity of bushes, trees and undergrowth. All the same, it is vital to know what goes on beneath the trees. Their growth and movement will be governed by the angles and slopes of the earth.

The form of the land is the basic structure, like the bones of

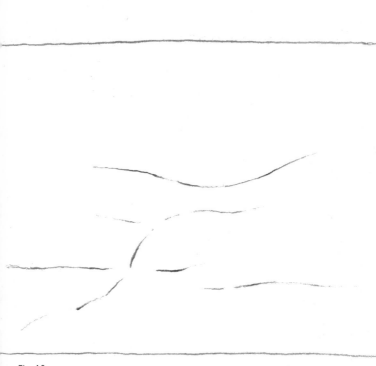

Fig. 10

the body. The rest of the landscape is just clothing.

I therefore began my first sketch (fig. 10) by ignoring the trees for the moment and emphasizing the main lines of the land. I had at the same time decided how much sky to allow in relation to the page.

It sometimes helps in the early stages of a drawing to regard the subject through half-closed eyes. This has the advantage of cutting out all the distracting details and simplifying the shapes before you.

In fig. 11, I have continued my first sketch by quickly and roughly working in the trees, bushes, fence and so on. Using those first few lines as a guide I now tried to capture the movement and character of my subject. If you compare this drawing with the photograph on page 20, you will see how much I left

23

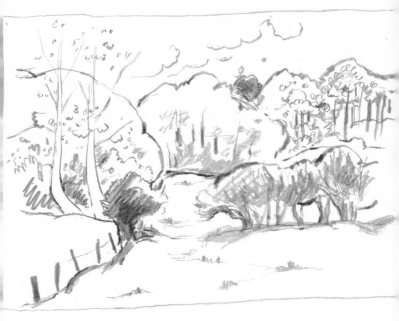

Fig. 11

out, either because I didn't notice it at the time, or because other things seemed more important.

Note how I exaggerated the angle of the tree, omitted all but the most emphatic branches, and stressed the structure of the land.

Never understate or be afraid of emphasizing what you consider relevant or exciting in the landscape. It is the artist's privilege to chop and change wherever he considers it necessary. Exaggerating in drawing is not cheating. It is merely a means of stating a fact in a more forceful manner. It is like underlining a sentence or word. Students of drawing are too often cautious in this respect. They feel that to suppress, diminish, or exaggerate would be dishonest. It is not. It is the very essence of drawing.

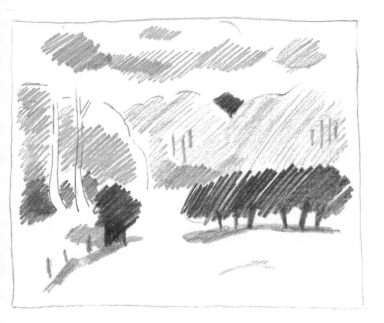

Fig. 12

Further sketches

In the next sketch (fig. 12), I approached the landscape from a very different but very necessary point of view. It is a tonal sketch. In other words, I concentrated on the lights and darks and simplified all the shapes down to their basic silhouette forms. This process of simplification to a flat pattern will help you decide what is right or wrong about the design on the page. You begin to see the shapes in relation to each other, and I do not mean only the shapes of bushes or clouds, but the shapes between them which are equally important.

Again, the trick of observing the landscape with half-closed eyes helps you to see the forms in terms of one mass against another. Darks can be seen in relation to lights, darks in relation to other darks and so on. Through this means you can discover what the landscape really consists of without the distraction of smaller details.

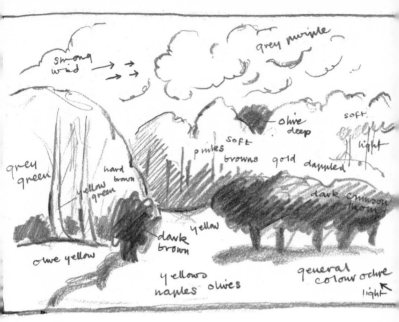

Fig. 13

In my third drawing (fig. 13) I returned to a more representational style, in view of what I had learned from the tonal study. I made notes about the light and wind directions.

I also jotted down reminders about the over-all colour and the more important colour details. You must use your own language for this purpose; for instance 'dusty pink' may conjure up a distinct image of a soft warm colour for one person, where the same words may suggest a dirty mud colour to someone else. It does not matter what you write down, provided it makes sense to you later on.

In this drawing I allowed more space for the sky; I was beginning to appreciate the quality of the sky and its effect on the landscape. I often do a separate sky study, encompassing more of the sky than I shall be using, in order to understand the nature of the cloud movements.

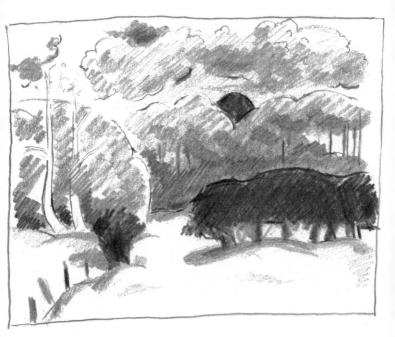

Fig. 14

Equally, when something is likely to play a prominent part in the painting, such as a certain tree, gateway, house or cloud, a more detailed study or a close-up, on a separate sheet of paper, can be most useful. At the same time, it must be strictly remembered that you are composing a landscape and that all the ingredients, whether shapes, colours, textures or lines, must work together as a team. However beautifully a tree is painted, it becomes an eyesore if it fails to rest comfortably in relation to the trees beside it. It is rather like placing a modern plastic chair in a Queen Anne interior. In fact, arranging shapes and colours on a canvas is not unlike furnishing a room. Both have to be designed to work within the limits of a rectangle. It may be necessary for the good of the ensemble to remove a tree or to sacrifice a lovely piece of furniture which doesn't fit in with the rest. Only you can decide.

3 Sketching

In speaking of the working drawing, we were concerned with a drawing in direct relationship to the landscape to be painted.

This is not to infer that other kinds of drawing are invalid. The artist should never be without his sketch book, and to become expert at the working drawing, constant practice with pen or pencil is essential.

So, before moving on to the next chapter, a word must be said about sketching, whether the subject is a dustbin (garbage can), a bowl of fruit, a leaf or a stone. Whether it is done indoors or outdoors, sketching is never a waste of time, because it is the only way to train the eye to see and the hand to obey.

Beware of quick, facile drawings which are concerned with the superficial appearance of things. Don't try to draw in the style of any particular artist. Most probably years of struggle got him there. And drawing, like handwriting, is an individual means of expression — it must remain a personal exploration.

The secret of drawing is to draw not what you think the subject ought to be, but to look again and rethink it, find out what it really consists of.

Look for the underlying structure in any natural form. Decide what are its most important features, what must be emphasized, what can safely be left out. Always look for the leading lines, the directional force (see page 59). Remember that it is far better to draw for short concentrated periods (and this may mean only five minutes of intense and searching work) than for three hours in a vague and unthinking manner.

Only when you bring your full intelligence to a subject, whether it be a cabbage leaf or a mountain, will you learn and develop and, consequently, make any real progress.

Fig. 15 Plant drawing by Leonard da Vin (Royal Library, Windsor Castle)

4 Composition

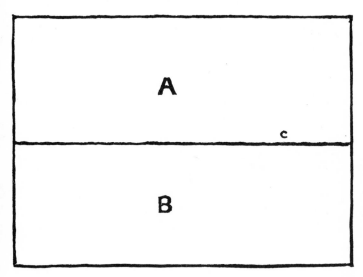

Fig. 16

The moment you place a mark on a sheet of paper, with intention, you have composed. The choice relating to the size, weight, shape and position of that mark is yours. It gives rise to endless possibilities. How do you decide between them?

I have already stated that one of the advantages of painting from the working drawing is that the major compositional decisions can then be made at an early stage. Thus, when the painting is begun, one task at least is simplified. But what are these compositional decisions?

For the time being, we shall confine ourselves to the flat or two-dimensional design within a rectangle.

If we begin by drawing a line across a sheet of paper, as in fig. 16, three elements are at once created: the presence of the line makes a shape above the line, A, a shape below the line, B, and the line itself, C.

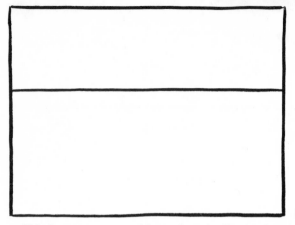

Fig. 17

This becomes more evident when the line is placed in a more interesting position than precisely half way up the rectangle. You can see more clearly that this is not just a rectangle divided into two, but that the division creates two distinct shapes. Fig. 17 has already more variety than fig. 16.

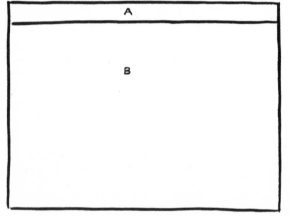

Fig. 18

In fig. 18, the line is now placed even higher, and B has become so large a shape in relation to A, that A looks as though it were being pushed out of the rectangle by a relentless B. It is obviously a less comfortable arrangement than fig. 17.

It would seem, then, that even the placing of so simple a thing as a straight horizontal line is a question of composition. Having discarded the dull symmetry of fig. 16, and the lack of balance in fig. 18, we realize that the line is happiest somewhere between the two extremes.

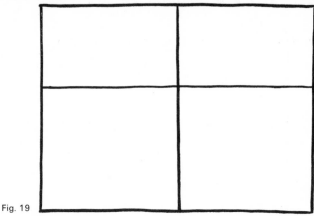

Fig. 19

Returning, therefore, to an arrangement similar to fig. 17, what occurs when another line is introduced? This time a vertical line is placed centrally (fig. 19). A more complex situation immediately appears.

Not only are there four new shapes, A, B, C and D, but in

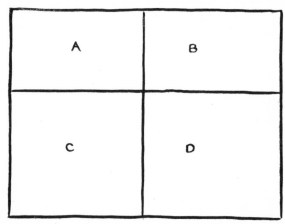

Fig. 20

crossing two lines over one another, a series of relationships now occurs within the rectangle. By placing the vertical line in the centre, two shapes, C and D, have been created, that are similar in size and shape and that outweigh A and B (fig. 20). C and D have consequently a closer relationship to one another than either of them has with A or B.

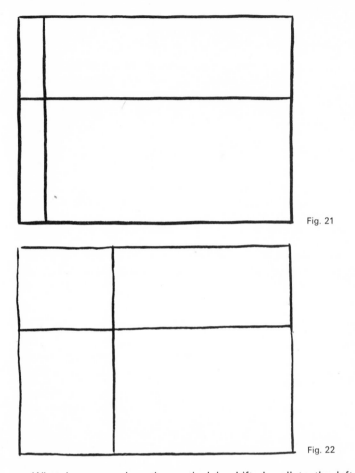

Fig. 21

Fig. 22

What happens when the vertical is shifted well to the left (fig. 21)? B and D now become so dominant within the composition that although not in fact the same size, they form a closer relationship to one another than with A and C. They completely dwarf poor little A and C, so that whereas in fig. 20 the composition could be said to seem bottom heavy, in fig. 21 it is lopsided.

In fig. 22 the vertical line is placed between these two extremes. The result is at once more comfortable without being dull. The four shapes become different sizes and the dividing lines different lengths. Balance and order are maintained while variety and interest are not sacrificed.

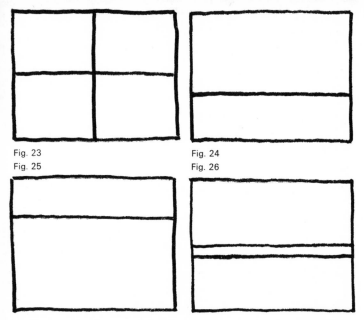

Fig. 23
Fig. 25

Fig. 24
Fig. 26

Almost any arrangement concerning two lines would be more interesting than fig. 23. Can you see why this is so? In fig. 24 and fig. 25 I have placed two horizontal lines; mark in for yourself, with a pencil, one vertical line in fig. 24 and two vertical lines in fig. 25, wherever you like. If you dislike the result, rub them out and try placing them differently. Now try fig. 26.

In nature, of course, there are almost no straight lines. In addition to the horizontal and vertical, there are curves, angles and spaces or the three-dimensional element, etc. So far we have only considered the most elementary form of composition.

Nevertheless, it is worth remembering that Mondrian, a fine landscape painter and draughtsman, discarded the figurative to devote all his time to the mysteries of composition at its simplest level. In fact we begin to realize that it is not as simple as all that; nor is it difficult to understand.

Already we have seen that in composing a picture consisting of two lines, the aim is to achieve balance and harmony without the use of uninteresting repetition and symmetry.

A large square does not necessarily have to be balanced by another square, equal in size and shape. Because this tends to be a boring solution, other means of maintaining balance and order must be found. It becomes a question of which arrangement will appear most comfortable to the eye while at the same time retaining maximum interest.

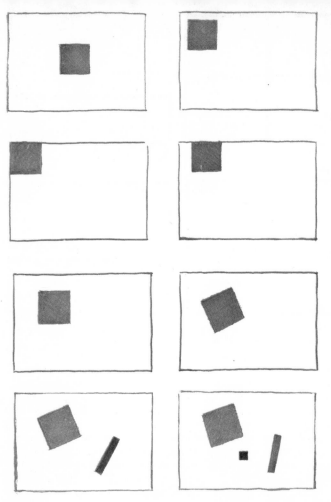

Fig. 27

The designs above show a few of the infinite number of possibilities involved when playing around with such simple shapes, using black and grey and, of course, the white of the paper.

Take a large sheet of paper and, using black and grey only, try for yourself as many designs as you like in a similar manner. It may seem child's play, but it is surprising how this game can heighten your awareness in regard to conscious placing.

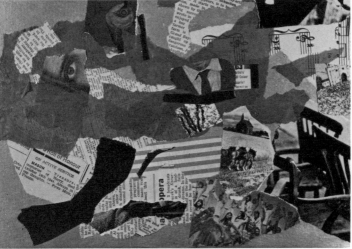

Fig. 28 Tissue paper collage **A** using one colour only **B** collage composed of different kinds of printed paper

You will discover when painting begins that these exercises have served their purpose.

The next stage is to compose from quite arbitrary shapes, and now we move nearer to natural form. The best method is to cut or tear paper shapes, using only black and grey paper to begin with. Try several designs, pushing the shapes around, letting them overlap or pile on top of one another. When you are satisfied with the composition, glue them into place.

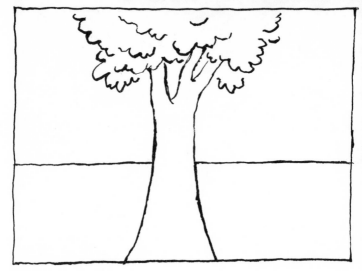

Fig. 29

Again, I think you will find that some arrangements or shapes in relation to each other are much happier than others. You will find yourself rejecting one form because it is too large, another for being too narrow, and so on.

Of course the most important element in any painting is its spirit, the feeling and enthusiasm that bursts from the canvas, without which you will just have a dull, nicely arranged composition. On the other hand, unless inspired feeling or vision rests on a firm underlying structure, you will end up with a painting that is like a body without bones.

So far we have only considered shapes in relation to flat abstract pattern. You may feel that the experiments in black and white have no connection with trees and fields or the landscape you are about to paint.

Where the tree, cloud or cow is placed, how light or dark, how much or how little emphasized, is going to be just as vital to the design as a whole as was the particular position of those two lines within the rectangle.

For instance, in fig. 29, a large tree in the foreground, placed in the centre of the picture, tends to cut the composition into two sections. Despite the horizon line which continues right through, this is obviously uncomfortable; worse, it is dreary. You are left with two equal sections on either side of the tree.

In fig. 30, by moving the tree a little to the left, the composition improves slightly; but because the tree is cut off at the top and bottom, it still succeeds in isolating itself from the rest of the

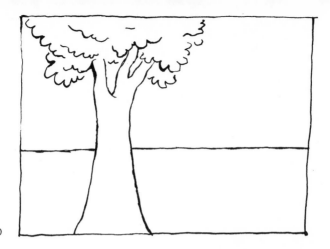

Fig. 30

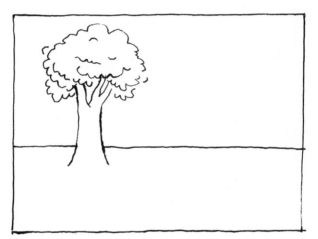

Fig. 31

picture and splitting the design into three parts, the tree, the area on the left of the tree and the area on the right.

Apart from removing the tree altogether, and since we must assume this is not what is wanted, how can the problem be overcome?

There are an infinite number of different solutions. The first and most obvious is to draw the tree from a greater distance so that all of the tree is included, as in fig. 31, in which case it becomes part of the landscape as a whole. However, this is not always possible, and to be true to the landscape in question, part (or parts) of the tree may have to be out of sight.

37

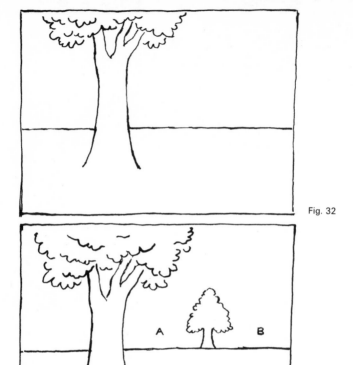

Fig. 32

Fig. 33

This is more likely to be so with the upper branches (fig. 32). The tree now looks easier than it did with both ends disappearing. On the other hand, the space on the right begins to look too empty; the tree is creating a top-heavy effect.

Perhaps there is another smaller, or more distinct, tree on the right of the first one. By introducing one, as in fig. 33, the eye is inclined to move across and into the picture; the small tree creates a sense of scale and space. The relationship between the trees is immediate, not only because they are the only two verticals present, but because trees, however they differ in species and type, provided a psychological link.

But in placing the second tree on the right, we have ignored the creation of two new shapes, the one between the two trees (A) and the one between the small tree and the side of the picture (B). A second look reveals that the spaces between each

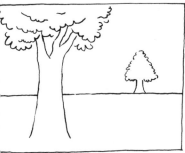

Fig. 34

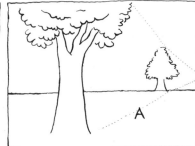

Fig. 35

tree and the edge of the rectangle, and that between the two trees, are similar in width, so that, however many cows or other forms we may intend to introduce, the composition is liable to be dull.

In fig. 34, the smaller tree has been shifted slightly to the right. The spaces now have more variety. The result of this move is to make us more aware of what occurs spatially. The eye is led from the large tree to the smaller one and beyond into space, and out of the picture as it were. There is a lack of any one thing to retrieve the wandering attention, and this produces a lack of balance. A form at point A in fig. 35, perhaps a sheep, cottage, path or bush, is needed to retrieve the balance. Three trees would be a more interesting number than two, so that a third tree or bush might be a solution; but this would lead onto the next problem: too many verticals. Verticals tend to have a more powerful effect than horizontals. The composition would in all probability benefit by the addition of horizontals such as hedges, fields, or strong shadows from the trees.

In the case of landscape painting, it is a question of using what you have got. This may be a group of cows, a road, a chalk pit. Whatever it is, it must always be seen as more than just an object or a feature of the landscape. It can provide a visual full stop, a horizontal rectangle, or a rectangle placed at a certain angle, and so on — in other words, it will become an important part of the total composition.

You can, of course, select landscapes that are not going to present too many compositional hazards, but often it is just the exaggerated angle of a tree, the slope of a haystack, or the unusual shape of a hill or gate that gives delight in the first place. To remove it is to remove all the excitement.

Nature is so full of variety, surprises and curiosities that, to bring any life to your landscapes, a means must be found to contain them.

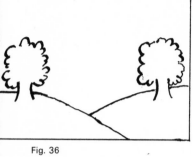

Fig. 36
Fig. 38

Fig. 37
Fig. 39

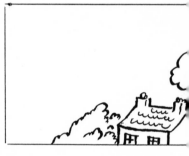

The designs above show how dull a composition can be when there are no such surprises.

Figs 36 and 37 are dull because they are so well balanced that the result is an all-over equality as boring as the centrally placed line.

Figs 38 and 39 show the opposite extreme, there is a complete lack of balance to the point of discomfort. It would need very strong forms indeed to counteract the type of problem shown here.

Try putting the designs to rights yourself, using a simplified figurative shape or shapes to adjust the balance. This can be done with pen or pencil or by using cut-out shapes.

I have mentioned already the importance of the shapes between objects. The passages that link one form to another are of particular importance in landscape painting. The eye should

Fig. 40 *The Slate Quarries* by John Crome (Tate Gallery, London). If you look at this painting upside down you will see what I mean by the concealed connection between one shape and another

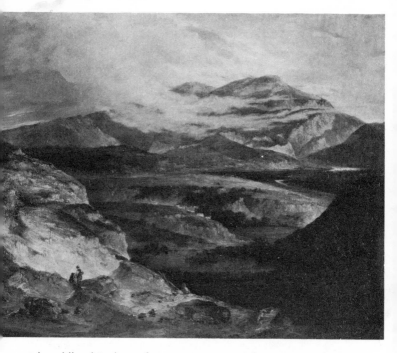

not be obliged to jump from cottage, to path, to tree, or even from tree to tree. To harmonize, these things should flow into one another.

Consequently, the shapes that occur between objects must be regarded as important forms in themselves. Now this is simple enough where there are recurring forms such as a row of trees which already provide a natural link, but how do you cope with the passage between one group of trees and another when they are divided by a large expanse of field or water?

The answer is to find a more subtle means of linking one form to another and so create harmony and balance. Ever since the painting of pictures first began, the painter has realized that to bring conviction to his work, the painting must not be seen in its parts, but as a whole. There must be secret links within his composition to provide an over-all harmony. By stressing a form

41

here, an outline there, a colour or a curve, the eye can be encouraged to move from one given shape to another without being aware of doing so.

There is, contrary to belief, very little difference between drawing and painting. Both are concerned with the relationship of light and dark, of shapes, lines and masses within a given shape, usually the rectangle.

In theory, if you can compose successfully in black and white, you can compose in colour. The difference is that colours not only have differing effects on our emotions (see chapter 6, page 53) but they also vary in the weight and intensity they carry. There are warm and cold colours, aggressive and recessive colours, hard, soft, disturbing or restful colours. We know more or less what a black square is going to look like beside a grey, or which will appear the most dominant. What happens when a blue is put next to a red, or a purple next to a green?

When translating a tonally constructed design into paint, it is going to be necessary to know what different colours may do. With this in mind, it is worth while doing some colour experiments on paper before painting the landscape.

These experiments might be done in watercolour, oil colour, chalk or pastel but one of the best media is coloured tissue paper which, although limiting your colour range, has some of the qualities of oil colour since it is semi-transparent. This means that a sheet of pink paper laid over white will show the white beneath. If a piece of yellow paper is then placed over the pink, an orange is created that still does not obliterate the optical advantages of the white.

Try making some entirely abstract compositions using torn pieces of couloured tissue paper on a white background. These can be glued down using a thinly applied coat of transparent glue.

At first, it is advisable to stay within a very simple colour range, preferably on the same side of the spectrum — browns, reds and ochres, for instance. Do not forget the white of the background. Use all sorts of sizes and shapes and enjoy yourself arranging and re-arranging them.

By about your third composition, you will begin to notice that some colour arrangements are more satisfactory than others. You will have grown more critical of your choice and placing of certain colour forms.

A collage that is constructed out of cool colours, blues, greens and greys, is obviously going to be thrown off balance compositionally when a sudden piece of scarlet is introduced. However, not all blues are necessarily cool. A blue with a little purple added begins to be warm, and placed beside an acid green can appear to be distinctly hot. Equally, red need not necessarily be hot, nor need the appearance of a piece of scarlet necessarily throw the design off balance. It is also a question of proportion. A small piece of red may well be balanced by a large area of strong blue where a pale blue would fail.

In other words, the artist need not be afraid that his passages of warm sunlight will automatically leap forward or his shadow forms necessarily recede and thus spoil his composition. A colour can be toned down, made warmer or cooler, or put beside another which serves as a link between it and the others on the page. A colour can serve as a means of arresting the eye where this is wanted, or of creating harmony between other colours where required.

The choice of what colour to place next to the first is as significant as the single line within the rectangle. Just as we searched for it in lines, then in more figurative shapes, the aim now is to strive for the maximum variety and interest while achieving balance and harmony with colours.

After a few experiments, all this will be fairly obvious. The difficulties only arise when this knowledge is transferred to a figurative composition. You may know what occurs when a certain green and a red are placed next to one another, and wish to avoid doing this. On the other hand, your drawing and notes clearly state that this is what occurred, and if, as may happen, this was an important element in the landscape, the issue cannot be avoided. It must be resolved in another way.

Let us suppose that a landscape consists of two main features, a tree and a house. The tree at first glance is a bright green, the house a terracotta red; the land is grey-green. Since the land and tree are both green, the tree is going to look more comfortable, because of its closer relationship to the soil, than the house whose effect is liable to be so violent as to create two pictures instead of one.

You could put a little green in the roof of the house suggesting moss and a little red in the tree suggesting autumn, but this does

not entirely solve the problem. There is the question of the passage between the two. By borrowing colours from both objects and creating a colour which is neither wholly red nor wholly green, but has particles of both and combines with other colours as well, a relationship between tree and house can be established. The eye can pass easily across from one to the other.

It is not easy to realize your working drawing as an abstract composition. It conjures up, as indeed it should, a memory of the most subtle lights and colours. All the same, it is worth putting aside memories and sensation for the present and dissecting the drawing with the ruthlessness of the mechanic.

All the parts of a machine are geared to make it work faultlessly. If something goes wrong, the mechanic must search for that weak point. Unless he can find it, the machine cannot function correctly.

The various parts of a painting are no less precise or functional. Each part plays a different role, and a painting, while primarily conveying an idea or an emotion, cannot do so unless every passage of paint functions perfectly.

I therefore suggest that, as a final exercise, you try breaking down the working drawings into terms of an abstract design. Do as many small compositions and as many variations as you think necessary. The purpose of these exercises is to appreciate trees, hedges, clouds and so on, as circles, squares, triangles, verticals, horizontals, etc. Reducing the landscape to flat abstract pattern enables you to be more critical of what is to form the framework of the painting.

Begin with black and white designs, then translate these into colour compositions. They need be no larger than fig. 29 and should not be allowed to become too detailed or elaborate. To fall into this trap is to kill the urgency or excitement when it comes to the real thing.

Some painters, much to the detriment of their work, make the mistake of painting their landscape in miniature at first and then literally copying this on a larger scale for the final painting. Since their excitement is already spent, the larger painting is liable to be dull and disappointing. Something must be kept in reserve.

5 Beginning the painting

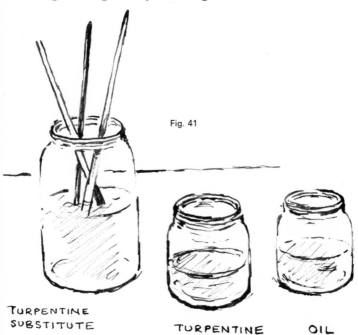

Fig. 41

TURPENTINE SUBSTITUTE

TURPENTINE

OIL

Ideally, the less time there is between the drawing and the painting of a landscape, the better. Whenever possible, the picture should be painted while the memory is still fresh and the idea still exciting.

Unfortunately, this is not always possible. A week or more may pass before time is found to begin painting.

Of course, inspiring drawings that immediately bring it all back are important. There is also a small trick which certainly helps. Make a definite point of remembering that particular landscape throughout the interval of waiting, by keeping it in your mind's eye whenever you can – whether brushing your hair or waiting at a bus stop. By hugging it rather like a secret, the image can be retained and even improved upon, and the anticipation adds to the excitement.

The first thing to do when you are ready, is to get your painting corner well organized. Decide on the size and shape of canvas, and place this on the easel, table or blackboard in a good light. The drawings can be pinned up nearby. The jars or tins should be filled with the midiums ready for use.

PURPLE REDS YELLOWS WHITE

BLUES

GREENS

BROWN

Fig. 42

Beginners often wonder how much, or how little, paint to squeeze out. This depends to a large extent on the size of canvas, the intended colour scheme and how thickly or thinly the artist works. I would advise painting very thinly, anyway at the early stages of any picture. It is safe to say that more space should be allowed on the palette for white than any other colour, and a generous allowance should be squeezed out.

A powerful colour, such as Cadmium Red or Winsor Blue, will go a long way. Normally very little is needed at a time, and less than the amount of toothpaste squeezed onto a toothbrush is usually sufficient.

At the end of the session, precious paint that is left over can be kept and used again by placing it in a saucer or shallow container, covered with linseed oil so that it is not exposed to the air.

White should be kept well separated from the other colours. A pale yellow is a sensible colour to put beside it, followed by the deeper yellows, browns, reds, purple, blues and greens.

Brushes can be washed during use by shaking in a jar of turpentine or substitute, then wiping on a rag. At the end of a

session, having been more thoroughly cleaned by this method, they should then be washed with soap and warm water.

Some people dislike a clean white canvas or find that it puts them off. The instinct to obliterate the white leads to rapid and ill-considered painting. When this is the case, a coloured base helps. A thin undercoat, using turpentine as a medium, should be applied, preferably well beforehand to allow it to dry throroughly. The colour can be applied very quickly with the 2-inch brush, then rubbed or dabbed over with a soft rag for even texture. It is essential that this base colour be in the form of a thin transparent glaze in order that the optical advantages of the white beneath are not lost.

The choice of colour for the undercoat must be related to the intended colour scheme. A bright red, for instance, would kill any subtle pinks you may intend to use. It is better to keep to a quiet neutral colour, such as a pale grey or brown.

I strongly advise standing up to paint. Sitting may be more comfortable, but it tends to lead to a cramped style and a picture that only works well in parts, not as a complete unit. Standing, on the other hand, enables you to walk away from the canvas to see it at different angles, or from a distance. You are altogether more mobile, freer and less restricted, and this will affect the painting itself.

Place a chair or sofa on the other side of the room. As the work proceeds you can collapse into this from time to time, observing the painting from a distance.

All important decisions are usually made from such a vantage point. If it is possible, hang a mirror behind the chair facing the painting; you will find it helpful to swing round occasionally and see the painting inside out, as it were.

The headache of where to begin, how to make a choice between one possibility and another, is simplified if you remain constant to the initial idea you had in mind. Your feelings concerning the original landscape, and its special pecularities, must dictate mood, pattern, colour and form. Many things may have to be sacrificed in order to retain the essence of that particular landscape. To convince, you must be convinced; if you are nervous and indecisive this will be communicated in your work and endanger your enjoyment of the process of painting.

Study the drawings carefully, particularly those first ones, and

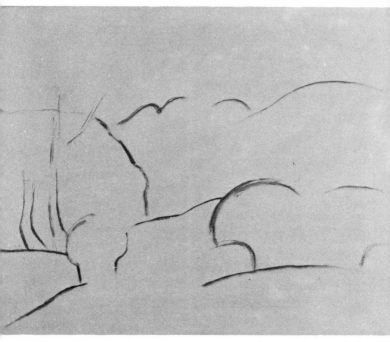

Fig. 43

regain some of the excitement and certainty felt at the time. Try to determine what was important and bear this in mind throughout the time of painting.

Before applying the main areas of colour, it helps to establish a few guiding lines. Limit yourself, however, to as few lines as possible. This is not the moment to follow the mass of intricate linear work which may be present in the drawings. Nor is it the time for details; they would be obliterated in the later paintwork anyway.

These guiding lines are merely to suggest the main divisions relating to the composition. Use the compositional studies, made from the drawings, to help you.

Charcoal is used by some artists to draw in these first lines. I prefer to use a pointed brush, as charcoal dirties the colours. The paintwork should be kept thin by using turpentine as a medium.

In the above illustration (fig. 43) I have begun my painting of

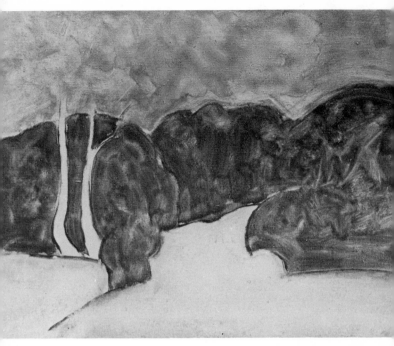

Fig. 44

the landscape discussed in chapter 2 by drawing in a few guide-
lines. I chose a dark brown on a very pale umber undercoat. The
undercoat was applied very thinly and rubbed over with a rag, as
described on page 47.

I was now ready to block in the main forms or colours, using
the lines as a guide. In speaking of colour, I include tone; that is
to say, the lights and darks mentioned in chapter 1. Colours also
vary in the weights they carry. This is why colour is really the
same thing as form. In fig. 44 (above) I have started by filling in
the main colour tonal divisions; in this case, sky, land and trees.
The trees are dark, the sky grey and the land is light. At this stage,
the paint can be applied with the large round-ended brush,
rubbing the paint on thinly, and using turpentine only as a
medium.

The dominating colour scheme and tonal pattern is now esta-
blished. This is also the basic structure on which the landscape is
to hang. It is vital that these foundations are sound, and for this

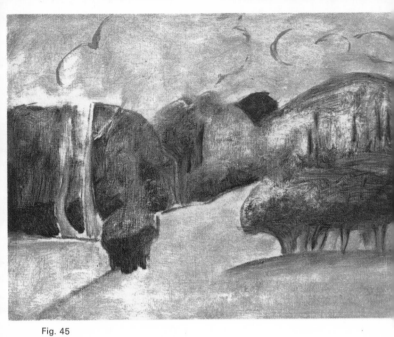

Fig. 45

Fig. 46

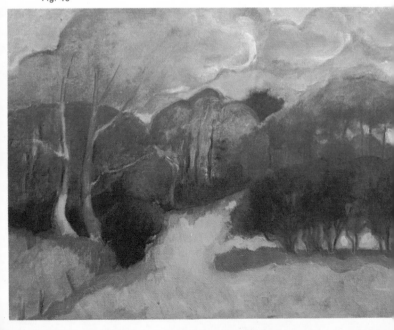

reason you should try to forget the drawings for the moment and judge the canvas as an abstract in its own right. Turn it upside down, or look at it in the mirror. If you are not entirely satisfied with these basic shapes, then, as you have wasted very little time or paint so far, it is worth wiping down and beginning again.

In fig. 45, I have moved on to the next stage, still keeping the paintwork very thin. I now emphasized the darkest passages within the trees and rubbed gently with a cloth any areas which were to be light. I rubbed in the over-all colour of field forms, and washed in the trunks with green. Using the pointed brush, I then drew in the main cloud and tree lines. The painting is still immensely simple, but it is beginning to draw a little closer to the more atmospheric drawings. It begins to emerge as a landscape.

At this point I broke for lunch. This meant that by the time I returned, the paintwork was dry. I could now start painting in earnest (fig. 46). I began to use the square-ended brushes as well as the round end and filbert. I also added oil to my turpentine. Using my notes as a guide, I began introducing other colours. I gave more body to the centre of the field with the help of thicker paint and brighter colour.

At once the trees looked thin and lifeless in contrast, so my next task was to give them more weight and greater variety. I realized that I had understated the thorn trees, so I made them darker and more lively.

I painted in the cloud forms very simply at this stage, they looked no better than lumps of cotton wool (absorbent cotton), but they began to relate to trees and shadow forms. I was attempting to regain the rhythmic wind-blown quality that I had first seen in the landscape.

In fig. 47 I have now moved into the last stage of the painting. At this point, it is possible to continue building up the details and enriching the painting, and sometimes this is necessary. There are no rules, it is the artist's privilege to push shapes and colours around, change, reduce or enlarge forms as much as he wants. You may choose to stress or obliterate details, in an attempt to achieve the landscape you have in mind.

Since the chief character of my Berkshire landscape lay in its simplicity and atmosphere, I was only concerned with details that would not detract from the mood I wished to create. Thus,

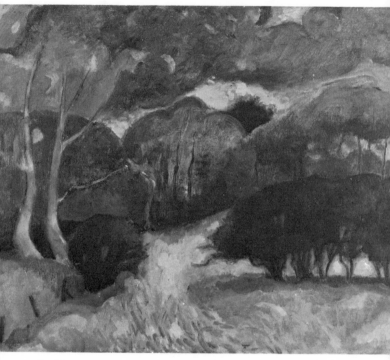

Fig. 47

I gave a little more scurry and interest to the sky by introducing further curves, and by using a fluffing technique (see chapter 6, page 74). I did very little more to the trees, as I wanted to keep them as fresh and full of movement as possible. Finally, I tried to give more variety to the field. I used the pointed brush and strands of colour similar to those in the trees and sky in order to achieve a closer harmony between these elements.

6 Developing your technique

I have whisked you through the last chapter as though there were no problems to painting a landscape.

If one did not encounter problems, it would be a boring pastime. Part of the fascination of painting is the challenge of new difficulties to be overcome with every brushstroke. Painting shares certain qualities with a game of chess. Every move made endangers or alters other pieces on the board. It is necessary to think several moves ahead, being constantly aware of every piece in relation to the others. But whereas chess ends with annihilation and destruction, good painting ends with an entirely new creation.

When painting a landscape, you must not forget that you are recreating or translating, not copying, nature. The world you have made must be complete in itself. Every passage of paint is as important as the next, and each has an essential function in the completed painting.

Sometimes you may find that, having painted your landscape strictly according to your notes, drawing and memory, the finished painting is in some way unsatisfactory. This is the moment to put the drawings away and study the picture for itself. It may be a question of colour, the shape of a field, a dull passage, a matter of texture or handling of paint, etc.

In the following pages I shall try to deal with some of these problems one by one. In fact, they are all interlinked.

Painting a picture is a question of placing many different elements together to make a whole.

Colour

Colour is the surface property of form and, as stated earlier, cannot be separated from its maker, light.

In any painting, colour plays an important role. But in landscape, where mood and atmosphere are so essential, special attention must be given to its properties. Colour has an effect on our emotions, it can convey moods of calm, turbulence, joy, sadness and so on. Equally, the way we see or react to colour can depend upon our state of mind or physical condition.

A student once said to me, 'The trouble with landscape painting is that it means such a lot of green'. (Green was not his favourite colour.) It was lack of observation that led to this remark. How

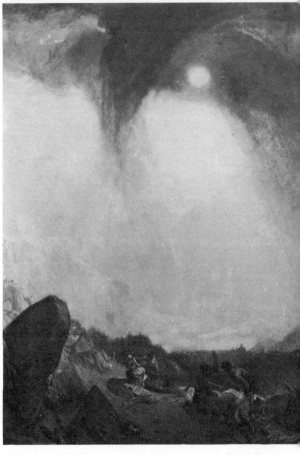

often is a field green? Grass can be white, grey, pink, yellow, brown, etc., or sometimes a chopped-up mixture of all or some of these, or of other colours. Green need not be the dominant colour in a landscape to make it convincing.

Some people seem born colourists; they hardly have to think about what colour should be placed beside another. But others experience enormous difficulties. If in doubt, it is better to restrict the palette to a small range, keeping the colours on the same side of the spectrum, i.e. browns, reds and ochre, or blue, greens and purples. Browns or greys need not be gloomy. An all-grey landscape with just a touch of colour can be more lively than a painting composed entirely of primary colours. In fact, a small dab of pink surrounded by greys has a more electric effect than a large slab of red surrounded by brilliant blue. It is a question

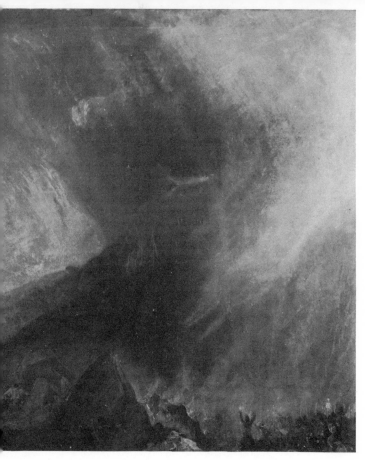

Fig. 48 *Snowstorm: Hannibal and his Army crossing the Alps* by Turner (Tate Gallery, London)

of balance. A cook does not add 6 oz. of salt to a cake because she has used 6 oz. of flour. A pinch of salt is all that is necessary.

In the same way, the painter must judge where a pinch of scarlet is needed, where a colour must be warm or cool, pale or dark, strong or weak.

In nature, there is no colour without gradation. There is a warm and cold side, a hard and soft side, a bright and shadowed side. Colour is not evenly distributed, it is broken, and as form recedes so the colour recedes, moving from warm to cool, from strong to weak. It changes as it diminishes.

There are no large areas of flat, unbroken colour in nature, because it is made up of many atoms of light, so that where you may decide a colour is bright green, on a second and closer look you may observe that it is made up of greys, dusty purple, yellow, blue and so on and only in one small spot gleams a brilliant green.

When starting a painting it would be inviting disaster to use as many colours as are to be found in a single field. You must select the general colour and tone needed, and a good way to do this is with your eyes half closed. But with the picture near completion, you may well feel that the colour is too much the same all over, that it needs feeding. Try introducing other colours, either by rubbing, stippling (page 74) or any other means, into this one colour, without destroying its general effect.

The art of painting is to take a second look at everything and to decide for yourself what colour it really is. Turner became the great colourist he was through intense observation of nature. He created some of the finest masterpieces ever painted by insisting that the only thing of importance to landscape should be light and colour. His paintings are a fine example of the necessity of maintaining balance by means of the equalization of unequal but equivalent colours or forms.

Light

There would be no colour without light, however stormy or clouded it may be and however little sky space is allowed on the canvas. The sun and light, its direction and strength, must permeate the canvas from one end to the other.

Landscape is light. The same scene changes radically in form and colour according to weather conditions, the time of day, the month of the year.

The mists that come in from the sea can cause an all-grey landscape, enclosed and mysterious, the trees flat silhouette shapes without shadow.

A strong wind clears these mists, bringing bright sunlight, and the landscape is transformed.

Both the passages of sunlight and the shadow forms must be realized as important shapes in themselves. These shapes must be incorporated into the general structure of the painting and not applied as later details, for they not only affect the over-all

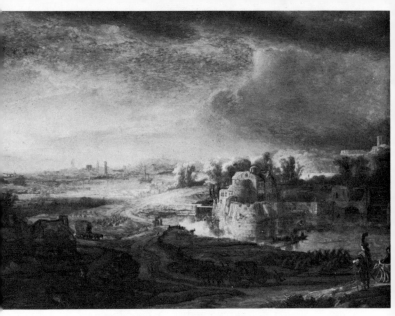

Fig. 49 *Landscape with a Coach* by Rembrandt (Wallace Collection, London)

design, but contribute to the mood and atmosphere of the painting right from the start.

There will always be one part of any given form which receives more light than any other. This can be rendered by a spot or slab of lighter colour. If this is not bright enough, i.e. if it lacks the brilliance and luminosity required, try scraping back to the white of the canvas again and allow the white to show through a thinly applied film of pure colour.

Equally important is the handling of the shadow forms. Again, there will be one point that is darker and more intense than any other. This may need a touch of colour, pure blue perhaps, to give vitality to that shadow area, and to match in strength the passage of sunlight.

In fig. 49, Rembrandt has used light to dictate the entire structure of his landscape. Individual objects and small details are bathed in waves of light or shadow. Other forms are broken up by partial shadow. By this means, one form is suffused into another, enabling the eye to float across and into the landscape. Note how in the shadowed areas there are passages still darker and more intense than others. Equally, in the sunlit areas there are moments when the light is brighter and the colours are more powerful.

Glazing

You may find that although correct in shape and colour, a particular passage in your painting has gone flat and lifeless. It is lacking the luminosity and glow you intended.

This may be due to clumsy paintwork, or the use of too much turpentine as a medium, or the fault may be remedied by glazing.

Glazing is a technique used ever since the discovery of paints. It consists of laying a thin film of one colour over another, so that the colour beneath glows through as it would through glass. The colour laid over the one beneath must be transparent. The first colour must be completely dry or the two will merge.

Glazing is of particular value to the landscape painter, enabling him to acquire the depths, glow and vitality present in nature. It can be used in one section or passage only, creating a warmer or cooler effect. It can be used to unite parts of a painting or the entire painting, suffusing the parts into a combined whole. It has its uses, too, in obtaining a sense of space and distance. It can bring about harmony or strengthen contrasts.

Time and practice will tell you where to glaze and what colour to use, but to start with it is worth experimenting with the effect one colour has upon another. For instance, try a warm Indian Yellow over a pale Cadmium Yellow, or a violet over this same yellow or Winsor Blue, and discover what powerful colours can be produced. Remember that the glazing colour must be kept pure, i.e. not mixed with white; it should be rubbed on thinly, using acrylic gel or oil as a medium.

Some of the old masters would paint the blue of their sky first, allowing this to dry out, then they would lay on a thin application of brown gold to obtain the deep olive green of foliage, the colour of which could never have been obtained by mixing. In the same way one red laid over another red will be more brilliant than anything you can mix on the palette.

Movement

There are two kinds of movement in landscape. The one you will immediately think of is the physical movement produced by wind on trees, grasses, scurrying clouds, waves, and so on. But there is another kind, important to the painter. Nature is never static; it is alive, changing or growing daily. In the case of land for-

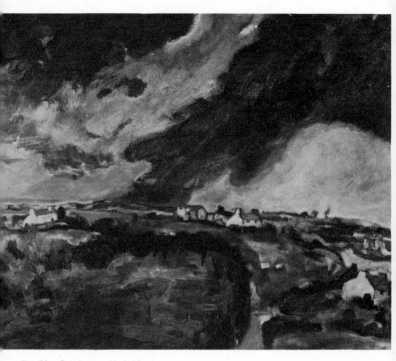

Fig. 50 Settrington, Yorkshire

mations, this happens slowly, in plant growth more quickly and in cloud changes rapidly. But to translate this vitality onto a flat canvas means understanding something of this movement.

There is a certain logic to be found throughout nature. There are leading lines and curves to be found in every form associated with growth, the tug of gravity, and other pressures.

For instance, every branch or twig of a tree has a logical direction or path to take. This is related to attaining the maximum light and sustenance for the tree. It is influenced also by the type of soil, the lie of the land, prevailing winds, competing plant growth and so on. Its particular path is also governed by the type of tree, the outer edges forming the great curve peculiar to the species of tree. In addition, there is always one branch or line stronger than the others, the leader, as it were, that sets the tune for the others.

The painter must look for this leading line in the tree, cloud or

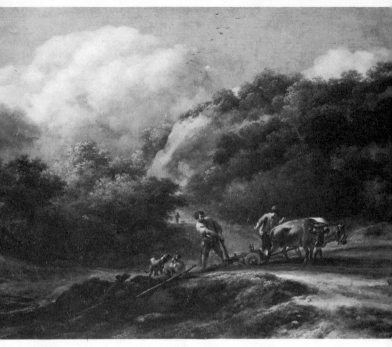

Fig. 51 Landscape by Rubens (National Gallery, London)

land formation which is the directional force for that particular form or series of forms.

Movement can be expressed by the use of flowing lines, shapes and curves, or by emphasis of certain forms that lead the eye in one direction or another, by a series of carefully placed accents built into the composition. A hedge, a clump of trees, a path, the line of a hill or field can all suggest a sense of direction and movement. It is a question of emphasis and balance. For example, a branch curves to the right, leading the eye out of the picture. To overcome this danger, without removing what is perhaps important to the character of the tree, more emphasis may be given to another shape of equal force to the left of the branch, and this brings the wandering attention back again, restoring balance and order.

Every small boy knows that to draw an airplane in the centre of the page gives less appearance of speed and movement than drawing it with its nose near the edge.

In the same way, painters, wanting movement and life in their

Fig. 52 *Farm in Tuscany* by Diana Armfield

landscape, must be prepared to take risks in relation to the edge of their canvas.

Whereas the airplane is intended to be on the point of disappearing, the forms in a painting must be controlled by other forms, and the movement confined within the four edges of the canvas. The edge is the precipice. The eye should not be led over this precipice.

In the painting by Diana Armfield (fig. 52) the sky charges out of the canvas to the left. In addition, a large farmhouse attracts the eye to the left. However, the attention is quickly arrested by the dark vertical form of a cypress tree, which acts to the design like a full stop to a sentence, and arrests the flow of movement. In this way, order is maintained but movement is not lost.

A more complex example may be seen in fig. 51, by Rubens. Here the eye is led round the picture, across and back again by a series of cunningly placed accents, curves, colours, lights and darks, and by the handling of paintwork and texture. The effect is one of nature at her most rampageous and alive.

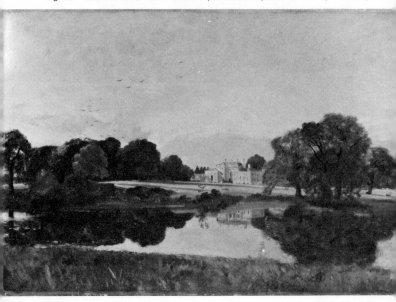

Fig. 53 *Malvern Hall, Warwickshire* by Constable (National Gallery, London)

Reflections and water

A pond or river, apart from its charm to any landscape enthusiast, is useful from the compositional angle. The headache of trying to relate two such different elements as sky and land is greatly reduced when there is a third element that combines the two.

Water combines the colours, luminosity and movement of sky with the reflected images of trees, buildings and other forms of land.

Remember that in any landscape water finds its own horizontal level and this should therefore run parallel to the top or bottom edge of your canvas. Consequently, where the light from the sky catches the surface of water, these strands or slabs of reflected light will be of horizontal nature. On the other hand, the reflected images from trees or forms in, or near, the water's edge will fall in a vertical line towards you.

A still pond may reflect the images so precisely that if looked at upside down the reflection, although a little elongated, could be mistaken for the reality.

The more movement there is in the water, the more distorted the images will be. A fast-moving river creates a series of ripples catching the light from the sky and producing either seriously distorted reflections or none at all.

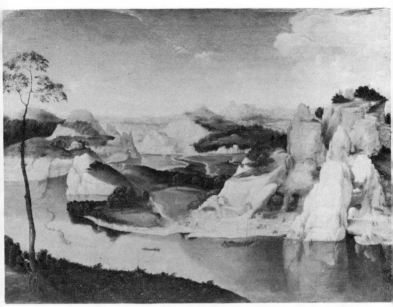

Fig. 54 *A River among Mountains,* Netherlandish School ?1525 (National Gallery, London)

Fig. 55 *The Mill Stream* by Constable (Tate Gallery, London). Note how simply the painter brushed on his slabs of white over a dark surface, to suggest light on water. This painting is also a fine example of trees and sky relating perfectly

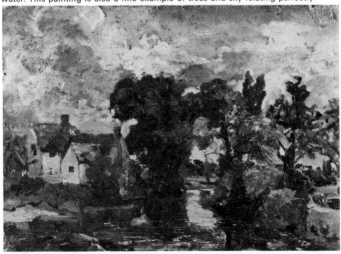

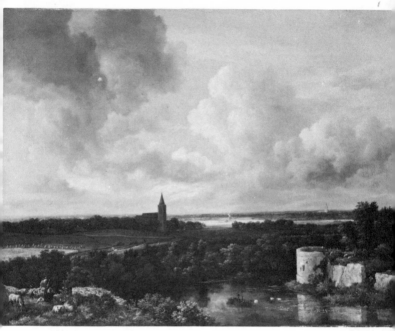

Fig. 56 An extensive landscape with a ruined castle by Jacob Van Ruisdael
(National Gallery, London)

When painting a clear blue sky, the luminosity of the white canvas showing through a thin application of colour helps the feeling of depth and distance. When painting water, it tends to be the other way round. A pond or river is dark at its base and only light on its surface, unless the water is very shallow and clear. A simple method, then, is to apply a dark and opaque undercoat, the reflected images introduced either at the same time, merging into the dark, or painted on top when the undercoat is dry. The slabs of light from the sky are laid on over the dark colour, and the whole area is then glazed over with a single film of colour (when the underpainting has dried out), giving the depth and luminosity of water.

This is just one way of painting water. But the most important thing is to treat it in relation to the rest of the canvas and method of painting.

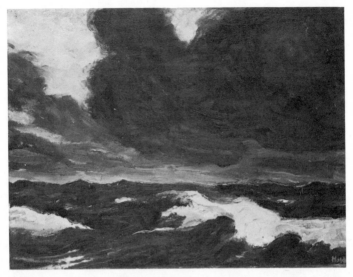

Fig. 57 *The Sea B* by Emil Nolde (Tate Gallery, London). The painter has given immense force and power to an initially simple subject. The two white shapes in the sky repeat themselves in the water, creating an immediate relationship between the two elements

Fig. 58 *The Storm* by M. V. Diaz (National Gallery, London)

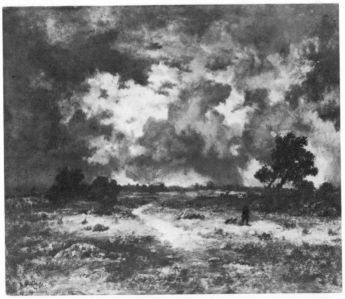

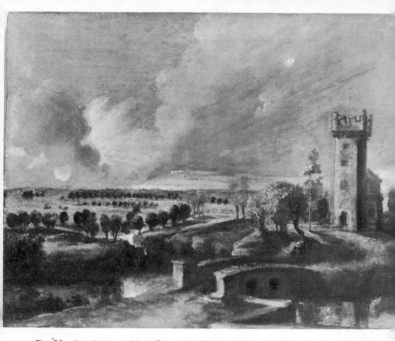

Fig. 59 *Landscape with a Tower* by Rubens (by courtesy of the Ashmolean Museum, Oxford)

Skies

Some painters find that the most difficult part of landscape painting is the sky: not the plain blue cloudless sky (see page 64), but the more interesting and constantly changing cloud forms.

In fact, provided it fits in with the logical development of the light and movement present, more fun can be had with the handling of skies than perhaps any other part of the landscape. Shapes and colours can be pushed around, changed or emphasized, stippled or scumbled (see page 74) and made to give power and atmosphere to the simplest landscape.

The sky is important because it affects the light, colour and movement of the land. It is part of the landscape and to see it as a separate entity is to cut the picture in half. During the drawing stage, notes should have been made regarding wind direction, its force, and the position of the sun. You probably did one or two quick drawings of the sky, showing the main cloud forms and their direction. They were necessarily quick because of the speed at which they change.

Now you are faced with translating these flimsy sketches into substantial forms. Look for the directional lines, the main weights

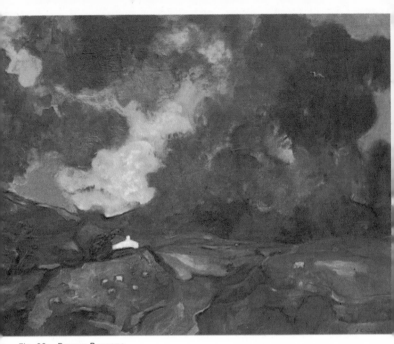

Fig. 60 Brecon Beacons

Fig. 61 Kent landscape

Fig. 62 Storm over Walberswick, Suffolk

and masses. Just as in a tree there is always a hard and a soft side due to the way in which the light falls upon it, so in a cloud there are dark and light, hard and soft, strong and weak sides. A sense of space and distance can be created by the use of warmer and more opaque colours combined with larger forms at the top of the canvas, slowly changing to cooler transparent colouring and smaller forms on the horizon.

At all times, both the colours, shapes and force of the cloud masses must relate to the land. Indeed, they can be very usefully employed in the composition. As a simple example, a heavy tree on the right hand side of the picture may be creating a lopsided effect. If the strongest weight in the cloud forms is also going to occur on the right hand side, the picture will practically fall out of the canvas. But if the emphasis is put on the left hand side of the

Fig. 63 *The Gleaners, Brighton* by Constable (Tate Gallery, London)

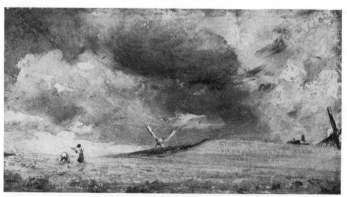

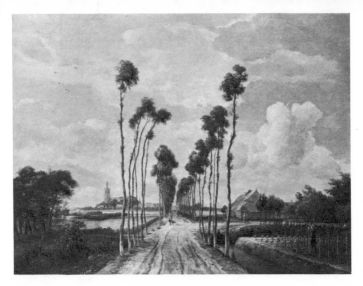

Fig. 64 *The Avenue* by Hobbema (National Gallery, London)

sky, the balance within the painting can be restored without
having to remove the tree. We have at the same time given the
sky such a useful job to do, in relation to the composition, that it
becomes at once an integral part of the entire landscape.

Perspective

The laws of perspective are perfectly simple to learn, but the
mathematical application of these laws is likely to harm the
artist's freedom of expression and his ability to judge with his
own eyes. In nature, perspective is not only a question of di-
minishing forms, but also of the subtle gradation of colour
changes.

In painting a landscape, we are attempting to create a three-
dimensional world on a flat canvas, so that, wherever forms re-
cede, a sense of perspective is established, and the more a sense
of depth and space is brought to the landscape.

Remember that your eye is the horizon level. All diminishing
lines or forms will slant towards that horizon level. If you are low
down, your horizon level will appear to be high and the receding
lines will slant up towards it. If you are high up, your horizon line
will appear to be lower and your receding lines seem to slant
down towards it. The imaginary spot on the horizon on a line
leading directly from you is known as the vanishing point. Thus,
if you are sitting in the middle of a straight road and looking

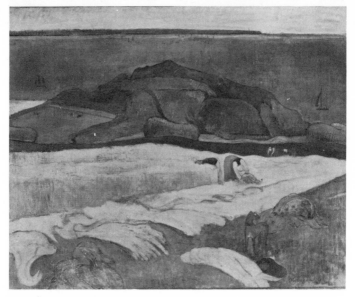

Fig. 65 *Harvest: Le Pouldu* by Gauguin (Tate Gallery, London)

along it, you will see that the parallel lines appear to meet on the horizon. The point where they meet is the vanishing point. If the same road takes a bend and changes its angle half way along, the former receding lines will still tend towards the vanishing point, but imagination must fill in the gap from where the bend takes place. To those who are worried by the rules of perspective, I recommend that they read *Perspective as Applied to Pictures* by Rex Vicat Cole (see page 101). It is worth doing some of the experiments advised. The principles involved can then be very quickly grasped, but you should not allow yourself to be hampered by the rules of perspective, and the best method of overcoming the problem is to use your eyes and judge the position of receding forms for yourself.

Proportion

So immense and varied is nature that it is hard to realize that there is, in fact, a universal law which makes almost any natural form a thing of beauty.

There is, however, a certain logic in all natural form that obeys mathematical laws relating to growth and pressures. These mathematical proportions are to be found throughout nature in all the shapes we known from the circle to the spiral.

Fig. 66 'It is not possible for two things to be fairly united without a third, for they need a bond between them which shall join them both.' Plato, *Timaeus* (31c)

Some artists reach instinctively for these proportions, recreating a thing of beauty; that is, without the use of compass and ruler they create proportions and relationships in their design that in fact conform to the mathematical laws found in nature.

The mystery and beauty of the universe, and the rules governing it as discovered by Pythagoras, need not concern the painter any more than the rules of perspective should, and I am not suggesting that you at once get to work with a tape measure and kill your instinctive enjoyment.

On the other hand, it is worth bearing in mind when a difficult passage occurs in a painting or some particular form, be it cloud, tree or shadow, or the relationship between them, that there is a known proportion generally regarded as being ideal. This ideal proportion, to be found throughout nature, is called the golden section. It is obtained by dividing a line in such a way that the shorter part is to the longer part what the longer part is to the whole.

This relates with the proportion of 2-3, 3-5, 5-8, 8-13 and so on, to be found so frequently in tree and plant growth. I have already suggested in chapter 2 that you avoid placing the horizon line half way up the canvas, because it cuts the picture in two. A 3-5 proportion is easier on the eye. The same applies to any other important features throughout the landscape; for example, the position of road, houses, mountain, trees, colours, patches of light and dark, in relation to one another.

Detail

Of course it is heartbreaking to have to remove or destroy a favourite gate, passage of colour, or texture, just because it does not work in relation to the rest of the picture. Unfortunately, this quite often happens. The reason for this is that, because it was a favourite, it received more attention than other parts of the painting. It was seen as a separate entity and not in relation to the other shapes.

This kind of frustration is often the result of earlier impatience to get everything down at the beginning. The small details in a painting must only come in at a later stage, and should only be

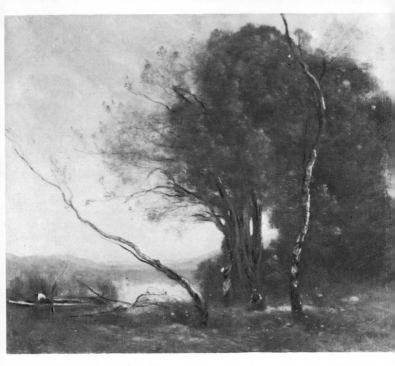

Fig. 67 *The Leaning Trunk* by Corot (National Gallery, London). This lovely paint-
ing in soft greys, with the yellow light of dawn just emerging, appears immensely
detailed, but the rich effect is obtained through the sensitive handling of paint. In
fact, only the occasional delicate line or blob is used to describe what occurs. To
have taken it any further would have destroyed the poetry

added at all where they will strengthen and enhance the design
and the mood of the landscape.

A brown blob or one single brush-stroke may be all that is
needed to represent a cow. A couple of pink dabs or a rectangle
of pink may be sufficient to suggest a cottage or building. You
know that the cow had four legs, and the cottage six windows,
but these are details that can either be added later, or may not
be needed at all.

Remember that it is the general structure and movement of the
tree that is important to your painting, not every twig. A delicate
fuzz of colour can suggest the immense intricacies of branches or
leaves much better than the painful leaf-by-leaf approach.
Beginners often think that a few details thrown in will help to
disguise discrepancies of design. They won't. However detailed
the old masters' landscapes, the details are governed throughout
by the larger design.

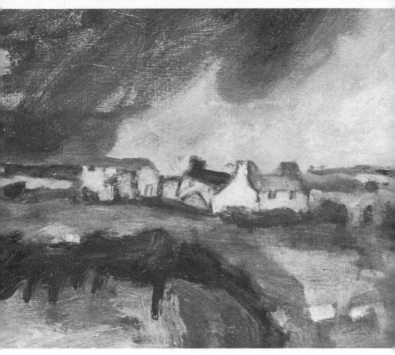

Fig. 68 Detail from Yorkshire landscape at Settrington (see fig. 50)

Where then, and at what point, do you introduce details? Here and there a form may need a little more emphasis, a little more variety or enrichment. At this point it is possible to do two jobs at once. For example, a streak of blue down the shadowed side of a tree trunk may be just what is needed to emphasize the vertical line, to deepen the colour, and at the same time imbue the tree with more reality.

In the same way, the pink slab which represented a cottage may appear to be too flat or dull and perhaps needs breaking up, and at this point a few dark squares or dots to represent the windows may improve the form as well as giving scale and reality.

In other words, details, where they are governed by the rest of the composition, can be used to enrich and improve the design. Properly handled, they can play an important role in the success of the landscape, but used for their own sake, or to compensate for a lack of basic form in a painting, they will detract from it or destroy its balance. It is the overall effect of the details, not the isolated gems, that count.

Texture and handling of paint

There is no rule which says that paint must necessarily be applied with a brush. Nature is so varied in texture that obviously there should be as much variety as possible in the painting without destroying the harmony of design. It may be done in parts or entirely with brush, palette knife, fingers, cloth, etc. The manner of handling the paintwork cannot be separated from the composition as a whole, and depends on the individual temperament of the painter and the ideas being expressed.

A brush is capable of the greatest variety. There is only one thing to avoid with the brush and that is the thick, even strokes of the house painter. This leads to a slimy and monotonous surface, never to be seen in nature and not deserving to be called texture.

Scumbling is a method of rubbing or scrubbing on a colour thinly with a brush. It may be used for all parts of the underpainting, for the merging of colours, gradation, for glazing work, for the blue of the sky and so on.

Stippling is a means of dotting or fluffing the paint on with a fairly loaded brush, as might be employed for the fluffy cotton-wool (absorbent cotton) type of cloud, the bark of a tree, surf, etc. (See fig. 58, page 65.)

Laying. The paint is applied in long or short strokes or a combination of both, often by means of a cross-hatching effect, using large and small squared-ended brushes. The strokes may be clearly visible (see fig. 69). In this way a large area of colour is given more variety through its textural application.

Drawing. The pointed brush, apart from its usefulness in drawing in those first few guidelines, may be employed where a line or blob needs emphasis, for dotting and for obtaining the linear chopped-straw effect needed perhaps for grass, leaves and so on.

Some painters work entirely with the palette knife, but I think this tends to lead to monotony of texture and lack of sensitivity. A composition is only bold and strong through its design, and not in the handling of paintwork alone. Nevertheless, paint applied with the palette knife has a fierce effect, and it can be useful where a hard and cold form, such as a rock or building, needs emphasis. You can also stipple, dab, or scrape down with a palette knife. Personally, I use the knife very little, and not at all for landscape paintings.

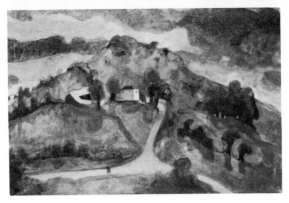

Fig. 69 Vaucluse valley, France

A cloth, on the other hand, quite apart from its use in wiping down parts of a canvas, can be employed for rubbing on a colour or for dabbing with a sponge-like effect, or for the gentle suffusing of one colour into another.

Of course there are any number of other means of obtaining different textures; painters have used sand, grit, sacking and string, and so on. But properly handled, the brush is capable of as much variety as any painting needs, and is far and away the best tool of all.

I strongly advise you to experiment on a spare canvas or piece of hardboard, trying out these different techniques and using a variety of brushes, in order to gain more confidence in handling paint.

Fig. 70 *Sacco e Rosso* by Alberto Burri (Tate Gallery, London)

7 Painting out of doors

Since most of the painting problems likely to be encountered are the same for outdoor as for indoor work, I shall deal here with only the specific difficulties peculiar to on-the-spot painting. I am assuming that by this time you have done several landscapes from your working drawings and now feel competent to work directly from nature.

In the studio, time may be taken over the painting. The great difference with working on the spot is that suddenly the light may change, the sun go down, or quite simply it rains. You will want to work quickly and not waste time desperately filling in the white parts of the canvas, so I recommend applying a thin undercoat of colour as a base on which to work. This can be done before setting out.

You may not have time for preliminary drawings, but time must be found for study of the landscape in front of you, before putting a mark on the canvas. The viewfinder will help you to settle the main compositional decisions, how much or little sky is necessary, how much wood or field, and so on. Try turning your back to the landscape and looking at it upside down between your legs. This may sound like acrobatics, but it has the enormous advantage of enabling you to see the landscape as a flat, two-dimensional pattern. The shapes are simplified to an abstract composition.

Put in the main guide lines or marks, as for a studio painting (page 48). Next, block in those first main colours or masses, keeping the paintwork thin so that it will dry out quickly. You may experience more difficulty in deciding on the exact colours, with the landscape right before you. When the sun is bright, a tree can seem brilliant yellow in parts and pitch black in the shadows. Try half-closing your eyes: now you may see that in general the tree is green. Although the lights and darks are an essential part of the structure, so is the general effect.

It is all too easy to be waylaid by the seductive number of details visible in nature. Remember what I said about detail on pages 71-3, and concentrate on the larger masses first, letting them merge together subtly. Strive to put down only what you consider essential. The essence of nature can often be described best by a few convincing marks that remain fresh, where a confusion of paintwork and colours may fail. To capture the mood and vitality of the scene before you is more important than including

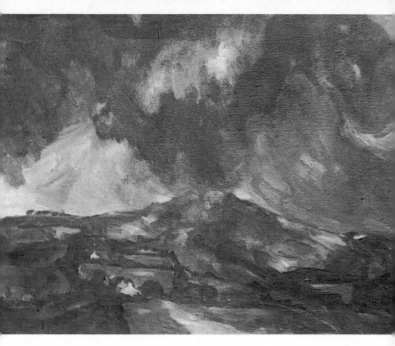

Fig. 71 Storm over Pembrokeshire. This painting was begun on the spot and completed in the studio over several weeks

the right number of telegraph posts. However realistic you may want the eventual result to be, it is the abstract pattern, the underlying structure, that gives reality, not the mass of detail or the leaf-by-leaf approach. You need not, therefore, be afraid to emphasize, alter or omit something, to change a brown field to purple, or to put green in a sky, if it will bring order and strength to the design.

It is a wretched moment for the painter when his entire landscape changes due to a change in light. If it is for the better, and it is not too late, make the necessary changes on the canvas. If this is not possible, then the previous conditions must be retained in the mind's eye while painting continues and with any luck the light may change again to what it was before.

You will find that the painting you bring home is very different from those done in the studio, and when you see it indoors both the colours and arrangement of shapes may seem less satisfactory. Nearly all great landscape painters, although beginning their pictures on the spot, finished them in the studio, and you will probably find that for you, too, this is the best way to complete the painting.

8 Looking and learning

Landscape painting opens up a whole new range of horizons. As you gain experience in drawing and painting, the more you will begin to use your eyes and find increasing pleasure in travelling through the countryside. Indeed, it is not until you have painted a few landscapes that you are likely to become positively ecstatic over the sight of a gate at a certain angle, the quality of a tuft of grass, trick of light or strange colour.

This is to be expected. What comes as more of a surprise to the beginner is a new and fuller appreciation of other painters' efforts. Your awareness of the problems involved heighten your understanding.

A great deal may be learnt from the study of works by the old masters. If you are unable to frequent a good art gallery or collection, it is worth investing in some books. The reproductions should be in colour and of high quality.

Do not be dismayed if you dislike the work of a certain painter, but try to analyse what it is that fails to please you. From this you will learn something about yourself and make progress. In time, a painter whose work you disliked before may suddenly be seen with a fresh eye, so that you find a new and unexpected pleasure in the study of his work. Equally, try to analyse what it is that delights you in another painter's work. Is it the colour, the manner of handling the paint, the composition? It often helps to turn the page upside down and see the painting in terms of a flat pattern.

The following pages show a selection of landscape paintings that provide examples of very different styles and techniques. Remember that, for all their differences, good paintings obey one law in common: they must work within the bounds of canvas, paint and method, as a complete unit.

Opposite

Fig. 72 *Moonrise on the Yare* by John Crome (Tate Gallery, London)
Crome expressed his great love for Norfolk in many quiet and sombre paintings. Their poetry lies in the simplicity of form which made him a painter greatly in advance of his time

Fig. 73 *Maryport IV* by Sheila Fell. Very different in mood from fig. 72; her paintings of Cumberland are intense, powerful and full of movement

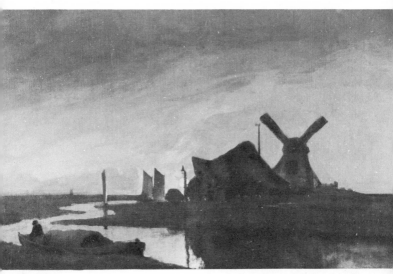

Fig. 72

Fig. 73

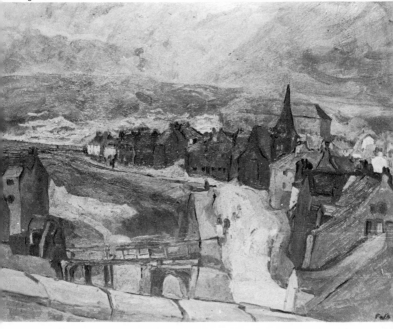

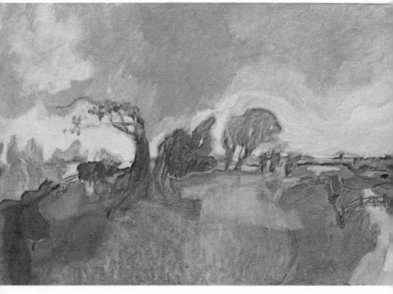

Fig. 74 Landscape in Kent

Opposite

Fig. 75 *Llyn-y-Cau, Cader Idris* by Richard Wilson (Tate Gallery, London). The first great English landscape painter was almost certainly Richard Wilson (1714-82). Perhaps the flamboyancy of the continental painters is more eye-catching and the landscapes of the Impressionist have tended to overshadow the innovations of some of the earlier artists such as Wilson

Fig. 76 *Paysage Brun 1967* by Henri Hayden. In complete contrast to Wilson, Henri Hayden uses simple convex shapes to express the sweeping calm of the Downs. He uses the minimum of detail to retain a mood of peace

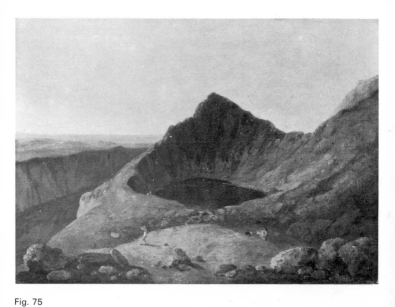

Fig. 75

Fig. 76

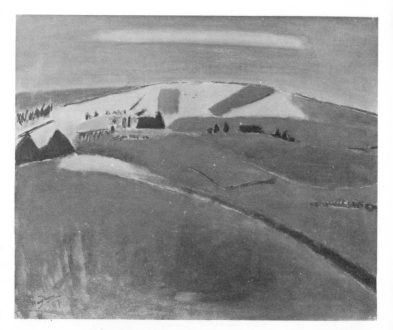

Fig. 77 *Tree near Trivaux Pond, c. 1916* by Matisse (Tate Gallery, London). Matisse has used a very different approach to trees compared with that of John Nash in fig. 79. Note how much of the white of the canvas is allowed to show through, and everything that is not essential to the structure is eliminated. In this way he succeeds in translating with perfect accuracy the fresh and vigorous quality of nature, the whole pervaded by sun and air. Only Turner could achieve such heights

Fig. 78 *Woman and Cows in a Country Road* by Sheila Fell. The Matisse landscape in fig. 77 is based on the vertical; this one is based on the horizontal. The paint is thickly applied in turbulent but controlled brush strokes.

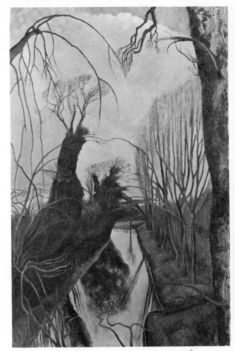

Fig. 79 *The Moat, Grange Farm, Kimble* by John Nash (Tate Gallery, London). A charming and tranquil landscape in blues and greys. Careful attention to certain details and the simplification of others create this very individual world

Fig. 80 *Painter's Landscape* by John Craxton. This is a very early Craxton, with something of the magic of Samuel Palmer. It shows the force of his vision and his strong sense of pictorial invention

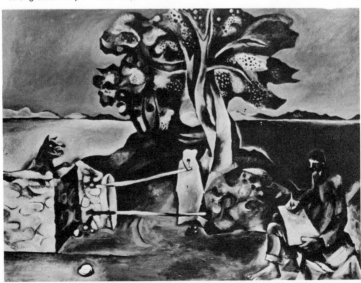

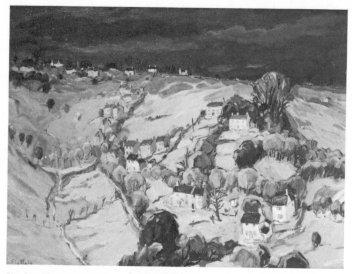

Fig. 81 *The Pink House* by Alaistair Flattely

Fig. 82 A Sussex Farmhouse 1969

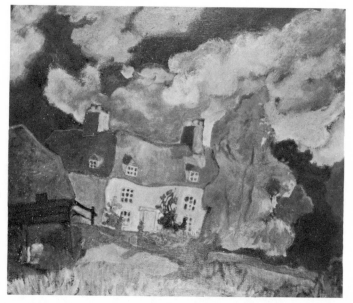

9 Stretching canvas and preparing other supports

Canvas, wood, cardboard, anything from a cornflakes box to your front door step, can be used as a painting surface. The only important thing when painting is to have a firm, non-porous surface.

Stretching canvas

Most painters would agree that of all the supports, canvas is the most pleasant to work on; but a ready prepared and stretched canvas is expensive to buy. The answer, then, is to stretch your own. This is not difficult and is, in fact, a rather satisfying occupation. Above all, it is economical.

The amount of canvas required to cover a stretcher can be left quite safely to your supplier, provided you state the size of stretcher. Ask for fine grain canvas, tight weave.

Stretchers come in pieces, or bars, for you to put together. Look closely and you will find that the pieces are slightly rounded on one side and square-edged on the other. In joining your four bars together, make sure that all the rounded sides face the same way (fig. 83).

Fig. 83

Fig. 84

You will find that the tongue-and-groove corners fit into each other quite easily, with a little pressure and by lightly tapping with a wooden mallet. If you haven't a mallet, use a hammer, but tie a piece of cloth over the end, for a hammer can damage the wood (fig. 84).

You will also have been supplied with triangular wedges or keys. These are only used when slackening occurs after the canvas has been stretched, in which case they should be tapped into the inside corners of the stretcher as shown in fig. 85.

Fig. 85

Fig. 86

When the stretcher has been assembled, lay your canvas on the floor with the stretcher on top of it. Cut out the canvas with scissors, leaving 2-3 inches to spare on all four sides of the stretcher (fig. 85).

Line up the weave carefully, parallel to the sides of the stretcher. Check that your canvas is placed *against* the slightly rounded side. This is important, for the square-edged side will cut into the canvas and make a ridge that will later be an eyesore.

Fig. 87

Attach your canvas to the stretcher in the middle of each side
with a drawing pin (thumbtack). Then, holding the stretcher and
canvas up on it side, lightly hammer in small carpet tacks in place
of the drawing pins (thumbtacks). These first carpet tacks should
only be driven in half way. They will be removed later (fig. 87).

Now place two more carpet tacks on either side of each centre
one, all the way round, pulling the canvas as hard with your thumb
and forefinger as you can manage. Return to the first side again,

Fig. 88

and drive the tacks in all the way (fig. 88). Repeat with remaining sides. Continue with this process, working outward until the corners are reached on all four sides. The tacks should be about 2-3 inches apart. Finally, return to those first carpet tacks placed in the centre of each side, and remove them with the claw of the hammer. When you have stretched until your thumb aches, drive them in again.

Fig. 89

Finish off your canvas by laying it face down on the floor and neatly folding in the edges at the corners, using either carpet tacks or drawing pins (thumbtacks) (fig. 89). The canvas is now ready for sizing.

Professional painters use canvas pliers for the thumb-aching business of stretching canvas, but I find I can do up to six canvasses at a go before my left thumb finally rebels. An alternative to carpet tacks is to use a staple gun. This is quick and easy, but the disadvantage is that you cannot drive in those first staples only half way, and pulling them out may tear the canvas.

Sizing

The next stage is sizing. Size is a glue which, when applied at a low temperature, i.e. just as it is setting on the canvas, forms a thin jelly-like film of glaze which prevents your colours from sinking right through the canvas. This is necessary whether you

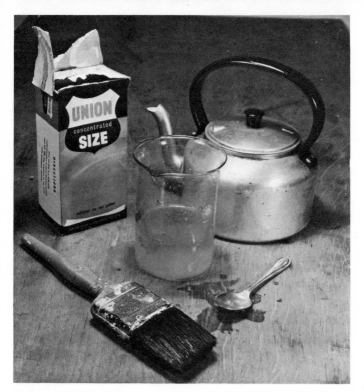

Fig. 90

use wood, paper, cardboard or canvas to paint on.

A packet of size from the local hardware shop costs very little. Place about half an inch of size in a jam jar. Stir in a small cup of cold water, leaving it to settle. Boil a kettle of water and then pour in the boiling water up to the top. Stir well, and put aside until it is tepid. If the size is too hot, it will go straight through when you apply it to your canvas. If it is too cold, it will already have formed a jelly and will not grip the canvas. Therefore, when you judge it to be at a temperature of 98°-99° F, scrub it on with an old paintbrush or washing-up (scrub) brush in a circular movement as though scrubbing a floor. It should froth as you do this. An open weave canvas will need two coats of size. You can decide this by turning your canvas round to see if the size is bubbling through the back. If it is, another coat will be necessary. The size should be allowed to dry out completely between coats. When both coats are dry, the canvas is ready for priming with white paint.

Fig. 91

Priming

Emulsion paint is useful for priming because it dries very quickly, but any stable white paint will do. Use a house painter's brush (fig. 91) and slap on one or two coats, sufficient to make a steely white surface. The canvas is now ready for use.

Other supports

Hardboard, wood or cardboard must also be primed if they are not to soak up the colours. Hardboard may be obtained in any size from a wood yard (lumber yard). It will need battens (thin strips of wood) round the edges at the back, to prevent warping. Larger pieces should have a cross bar also, and for very large sheets a diagonal support will be necessary (fig. 93). Attach the strips of batten with panel pins (brads).

Fig. 92

Fig. 93

Use the smooth side of hardboard for painting. The rough side may look more like canvas; but it not only eats up the paint, it also has an unpleasant mechanical quality which is almost impossible to get rid of. Hardboard is cheap to buy and easily prepared, but compared to canvas it is less sympathetic to work on and awkward and heavy to move around.

Prime hardboard, wood or cardboard as described for canvas. A coat or two of glue size and two coats of white are usually necessary for hardboard or any darker surface.

10 Varnishing and framing

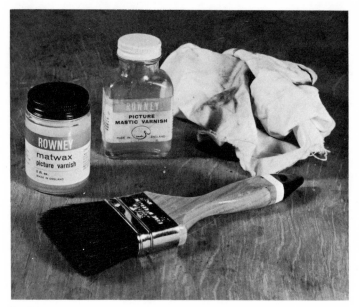

Fig. 94

Varnishing

Some time after a painting is completed it may seem to be a little dull or flat in places. The colours appear to have lost their glow. A thin coat of varnish will restore their vitality and serve as protection from the effects of dust and damp in the atmosphere.

The painting must be allowed to dry out completely before being varnished. Failure to do so will cause cracking. The time allowed will depend on the thickness of paint, the number of layers and the quantity of oil used. To be on the safe side, allow about six months before varnishing.

Make certain that the picture is free of dust. Clean with a slightly soapy, damp cloth. Wipe over and allow to dry overnight. Apply the varnish with a clean dry brush, or as recommended on the bottle.

Fig. 95

Framing

To have a painting framed by a professional picture framer is expensive. Any carpenter or joiner can make a frame with the use of a mitre block. I get all my frames made by a local carpenter, having bought the moulding in ten-foot or other lengths, direct from a moulding manufacturer. The choice of moulding must depend on the colours and style of the painting concerned. Where in doubt, stick to something very simple and neutral in colour; black or black and gold, grey or brown.

If you use this method of framing you can either take your paintings to the moulding firm and decide on the spot or bring home some off-cuts and think about it at leisure.

Make sure that you order enough to make the frame, by allowing one foot over the measured amount. This allows for the wastage which must occur on the four corners.

Fig. 96

Sometimes one can pick up frames cheaply in junk shops. Their designs are usually out of fashion, and you may find yourself painting pictures to suit the frame, but this can be stimulating. What about an oval landscape?

The third method of framing is to do it yourself, either quite simply by nailing battens (thin strips of wood) round the sides or by buying the moulding and mitre block and making your own.

Picture Framing for Beginners by Prudence Nuttall, in the same series as this book, will give you detailed information about this (see reading list, page 102).

Fig. 97

Figs 98 and 99 Some examples of frames suitable for landscape paintings

List of suppliers

Brodie & Middleton, 79 Long Acre, London WC2 (recommended for canvas)

Cornelisson & Sons, 22 Great Queen St. London WC2 (paints)

Alec Tiranti, 72 Charlotte Street, London W1 (books and materials)

J. Fisher & Sons, 21 Bevenden St, East Road London N1 (framing and moulding)

K. Scharf, 111 Goswell Road, London N1 (framing and moulding)

Roberson & Co. Ltd, 71 Parkway, London NW1 (stretchers, canvas etc.)

G. Rowney & Co. Ltd, 10/11 Percy Street, London W1 (all artists materials — their A42 drawing book is especially recommended)

Reeves & Sons Ltd, Enfield, Middlesex (all artists materials)

Winsor & Newton, 51 Rathbone Place, London W1 (all artists materials)

A. Zwemmer Ltd, 78 Charing Cross Rd, London WC2 (books on art)

The above list gives some of the main suppliers and manufacturers of artists' materials in Great Britain. These may be obtained at source or your local art shop will probably deal with one or several of these firms.

Unfortunately it is a fairly haphazard business and although you may find that the local art shop, or even stationers, stock the excellent Winsor colours, they may not necessarily have the complete range.

Where there is any difficulty in obtaining particular materials, it is always possible to send for the fully illustrated catalogue supplied free of charge by any of the leading manufacturers. Your supplies may then be ordered by mail or telephone, and this is sometimes the best way of getting exactly what you want.

Materials and equipment

All art suppliers, and most of the larger stationery shops or departments, supply drawing materials.

Drawing books Any art supply store and many stationers.

Pens, pencils, ink etc. Any art supplier.

Camp stool The cheaper varieties may be bought at a hardware store, or camping equipment shop. Art shops provide a selection of the lighter alloy models which are more expensive.

Easels Only the better-known art suppliers will have a wide range to choose from.

Brushes All art shops and good stationers provide a variety of types and sizes.

Paints The range is enormous. Stick to the better known makes and avoid student colours. I recommend Winsor & Newton.

Paints in powder form may be bought at Cornelissons, London (see page 98) and Fezandie & Sperrle, 103 Lafayette Street, New York, for those who like to grind their own.

Medium Turpentine, turpentine substitute and linseed oil may be bought at your local hardware shop at a much better price than from the art shop.

Pale drying oil, gel, varnishes, etc. may be obtained from most art suppliers.

Palette Only necessary if you propose painting out of doors, in which case buy a light-weight rounded one in white at any leading art shop, and a pair of double dippers that clip on.

Canvas Ready stretched and prepared from any art supplier, but this is an expensive method (see chapter 9).

Canvas by the yard Brodie and Middleton (London) sell rolls of sail cloth, and most large American art stores sell rolls of raw canvas. This is one of the cheapest methods of buying canvas, but make sure that it is unstarched.

Canvas and stretchers Roberson (London) supply a wide range of stretcher pieces and canvas at varying prices, as do most American art supply stores. They also provide ready-primed canvas by the yard, but this is more expensive. Canvas panels (canvas glued to cardboard backing) are less expensive and are widely sold in the U.S., but in my opinion they are much less satisfactory.

Hardboard, plywood, battening (wooden strips), etc. may be obtained from any local builders' yard (lumber yard) or even the

larger hardware stores. They will usually cut your pieces to the required size and batten the back where necessary.

Coloured tissue paper for collage work. This is best bought at an art shop; although obtainable from many stationers they do not always stock a wide variety of colours.

Glue For collage you will need a very transparent, non-dis-colouring glue that is easily applied. Any good art shop will advise you.

White paint for priming board or canvas. Your local art shop will probably stock the tins of priming paint which have size added. The new acrylic gesso is also convenient, but this is expensive; the better method is to use white emulsion or the slower-drying oil bound paints, to be obtained from local hardware or decorator's shops.

Size glue and a wide household brush are also obtainable at a hardware shop.

Varnish should only be bought at the art shop and the directions for use should be adhered to.

Frames A local picture framer will frame your pictures at great expense. Moulding in required lengths may be bought from Fisher & Sons or Scharf & Co. Ltd (London) and from similar suppliers in most major U.S. cities. Your local carpenter will then make them up for you at very little cost.

Moulding and battening Apart from the above recommended firms, the larger builders' yards (lumber yards) usually supply a limited range of the cheaper mouldings and simple battening. They will usually make up the frames too.

In the U.S., drawing and painting materials can also be obtained through mail-order catalog from the following sources:

Arthur Brown & Bro., Inc., 2 West 46th Street, New York, N.Y. 10036

A. L. Friedman, Inc., 25 West 45th Street, New York, N.Y. 10036

Joseph Mayer Co., Inc., 5 Union Square West, New York, N.Y. 10003

F. Weber Co., Div. Visual Art Industries, Inc., 2000 Windrim Ave., Philadelphia, Pennsylvania 19144

For further reading

The Elements of Drawing by John Ruskin; Allen and Unwin, London and Reprint House International, New York 1902

The Lamp of Beauty: Writings on Art by John Ruskin, ed. J. Evans; Phaidon, London 1959

The Artist's Handbook of Materials and Techniques by Ralph Mayer; Faber, London 1964 and Viking Press, New York 1957 (revised edition)

Colours: What They Can Do For You by Louis Cheskin; Blandford, London 1949 and Liveright, New York 1951 (revised edition)

Man and His Images by Georgine Oeri; Studio Vista, London and Viking, New York 1968

The Meaning and Magic of Art by Fred Gettings; Hamlyn, London 1968

Pedagogical Sketchbook by Paul Klee; Faber, London 1968; Praeger, New York

The Art of Pictorial Composition by Louis Wolchonok; Harper and Row, London 1961 and Dover, New York 1969

Perspective: The Practice and Theory of Perspective as Applied to Pictures by Rex Vicat Cole; Seeley Service, London 1951 and Dover, New York 1970

Landscape Painting by R. O. Dunlop; Seeley Service, London and Dover, New York 1954

The technique of Oil Painting by Leonard Richmond; Pitman, London 1969. Published in USA as *Fundamentals of Oil Painting;* Watson-Guptill, New York 1970

The Demands of Art by Max Raphael; Routledge, London and Princeton University Press, 1968

A Painter's Diary by Francis Hoyland; Educational Explorers, 1967

Painting as a Pastime by Sir Winston Churchill; Odhams, London and Cornerstone, New York, 1965

Landscape into Art by Sir Kenneth Clark; John Murray, London 1949 and Beacon Press, Boston 1961

Colour in Turner: Poetry and Truth by John Gage; Studio Vista, London and Praeger, New York 1969

Picture Framing for Beginners by Prudence Nuttall; Studio Vista, London and Watson-Guptill, New York 1968

150 Techniques in Art by Hanz Meyer; Batsford, London, 1963

Rhythmic Form in Art by Irma A. Richter; John Lane, The Bodley Head, London, 1932

A Treatise on Landscape Painting by André L'hote; Zwemmer, London

Index